AS I SEE IT

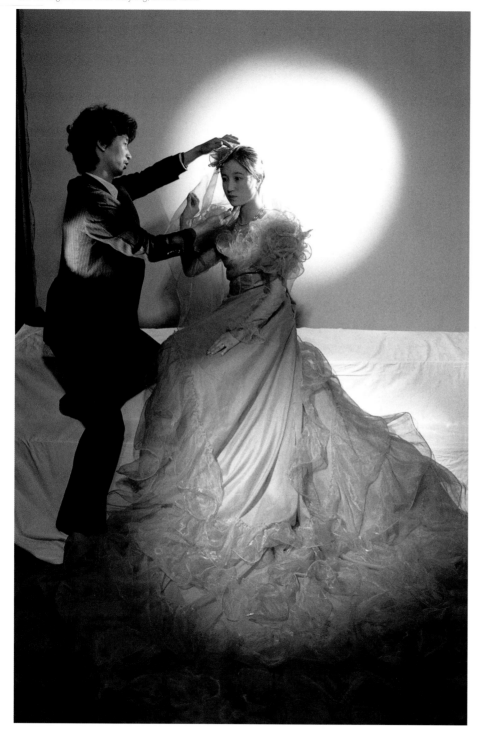

A BOB ADELMAN BOOK

John Loengard

AS I SEE IT

Introduction by Ann Beattie

THE VENDOME PRESS

Old Orchard Beach, Maine. 1972

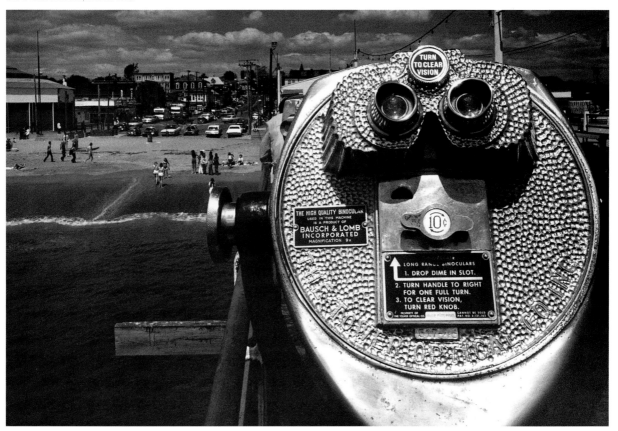

Preface

As I see it, my photographs, when gathered up, form a mixed bouquet. They have no single subject or topic. If commentary helps bind them together, so much the better. Since pictures speak for themselves, I write about what goes through a photographer's mind before and after the picture's taken. These thoughts go back to the first photographs I took before my twelfth birthday. Since then, I've met many others who fell in love with photography at around that age. Invariably, *magic* is the word we use to describe what we discovered. Still, the fact is, photographers work only with what's present. I suspect our chief emotions are anticipation, frustration and patience (if that's an emotion)—balanced by a marvelous sense of elation when things go right: when we think we've captured in a photograph some missing feeling, or hidden beauty, or bit of mystery from the fabric of life.

John Loengard

Commentary begins on page 172

Introduction

Ann Beattie

I have a friend, a very good poet, who takes offense when poetry is invoked to make specious comparisons between genres. He hates it if someone approves of a passage of fiction as "poetic." Therefore I cringe, though I can't help myself: one of the reasons I react so strongly to John Loengard's photographs is because I find them so literary. He has set about to reveal the inner life of his subjects, but his narrative must be evocative, connotational, rather than sustained and linear. In the photograph titled "The Acrobatic Theater" (p. 76), we see a giant panda riding a motorbike. It is a humorous, but discomfiting picture; one likely to provoke surprise, but also a what-has-the-world-come-to response. As a photograph, it's wonderful: here it comes, this odd creature, steering toward us as if it might break through the picture plane.

In his notes, Loengard writes: " 'A giant panda practices for the Tour de France,' was all *Travel & Leisure* magazine told its readers about this bear riding a motorbike at the Acrobatic Theater in Shanghai. If you could read the panda's mind, there'd be a lot more to say." That's an understatement, but it's also modest: Loengard instantly understood that it was the panda's story, and he offered it to us so we could not help but read the panda's mind. He involved us not from the distant perspective from which we might have viewed the scene, but through the eyes of the unlikely main character. (Also, what's interested him after the fact, after the photograph, is that the caption writer was no doubt amused to adhere to the convention of only factually presenting a photograph. This would amuse John Loengard, who often wonders,

within the context of his photographs, why conventions shouldn't be broken.)

Consider his famous photograph of the Beatles (p.127): Were these examples of shock-Ed-Sullivan exuberance best photographed as floating heads? Well, yes: because Loengard thought to do it and it worked. Without this image, they would remain the long-torsoed, mop-haired, upright musicians who overwhelmed a generation (or two); here, we're able to infer separate personalities by understanding the moment of the photograph from the separate perspective of all four participants in this Shanghai circus, so to speak. The world looks different (as we came to find out it did) to John, Paul, George and Ringo.

I think of John Loengard, however, as a perceiver of inner realities—and that is, again, why I think of him working as a novelist does. It helps if the subject expresses something marvelous, as Georgia O'Keeffe (p.21) did, displaying her favorite stone. It can sometimes be an advantage if someone closes his eyes for a moment (William Styron, p.149). But these things can work only if the photographer intuits something true about the subject, so that the moment of the blink isn't an outtake, but an interpretation. These photographs do not record extremes. Instead of going for the outburst, the genuine, big smile (not so many of those when you're the subject, I assure you), he finds a way to put himself in a symbiotic relationship with the subject, and then not miss the tenor of what is revealed (Allen Ginsberg, pp.120-1: "I sat on the floor in front of Allen Ginsberg..."; Lady Bird Johnson, pp.156-7: "Lady Bird Johnson, widow of the 36th President of the

United States, laughed at something I said"). I suppose lucky accidents happen all the time—think of how you met your mate, how you came to get your dog—but as far as I can tell, Loengard does not believe there's a litmus test of anything, so a so-called lucky accident offers no guarantee.

In other words, to provoke a subject does not guarantee you'll get the photograph you want; to befriend the subject does not make it more likely (one of Loengard's most amazing photographic portraits [p.92] is of the outcropping of houses his subjects, whom he didn't know, left before he arrived). In any case, manipulation would be beyond him. Oh, a little nudge, an astute leading question ... but he has a talent for considering how you want to reveal yourself (how you really want to reveal yourself, not a preconceived notion of how you should pose for maximum protection), and a talent, as well, for taking a photograph that gives the impression that that moment is—however real—just a second in time, not definitive. The panda cyclist opens the parameters of the picture and asks more questions than even the most long-winded novelist could answer. Similarly, the quality of an expression sometimes lets us know not just the obvious, that the subject has retreated, but that such an external impression of inward retreat shows us the paradoxical power, yet lack of power, any photographer has.

Jimmy Carter (p. 129), no different from all of us, cannot always look like this. He must have greeted the photographer, so there was the moment before the photograph, but the moment after it was taken seems even more worthy of our attention, which I think

the picture suggests: the hand will be lowered, eyes cast up. We're seeing him just before he reconnects with us, but we can imagine the moment to come.

People often ask fiction writers, "Why did you end it there?" What they're saying is that they judge the resonance differently than you: to the writer, the perfect word or image at story's end may echo for hours, but if other people hear on a different frequency, they don't get it. You know what? They won't. What's necessary is to try to connect with the artist's reality, and with this collection by John Loengard, that so quickly draws you in, there is ample opportunity to connect. You won't need anyone to point out the recurrence of hands (potentially as expressive as any face), or the emotional connotations of his having come in close or—just as revealing—having stepped back. He gives equal respect to the famous and the not-famous, equal respect to himself and to his subjects. He's a modest man, with the reflexes of a cobra.

When I look at his photographs, my silent reaction is, "Really?" Not that there's anything there to make me doubt them; there's nothing phonied-up or self-consciously artsy. Quite the opposite: Really, you're telling me that these people, inhabiting the same world I do, have been stopped in time without giving the impression that time has been stopped long enough to make a definitive, nondefinitive photograph? They resonate instead.

Years ago, in my quasi-youth, my husband and I were photographed by John Loengard. He came to Virginia— had we met previously, or did I only know his photographs, and know that we had a good mutual

friend? We went to a seafood restaurant, talked, had a good time, and the next day he came to the house and we started in. But the sofa I might have stretched on didn't have sides, so I slumped somewhat awkwardly, and what could my husband Lincoln and I do together that didn't seem made up for the moment? Loengard had but to ask, and I spontaneously admitted to what Lincoln and I thought of as "Bothering Michael"—our friend who ran a bookstore. The picture is here (p. 16), we are still here, Michael is too, though the store was run out of business by Barnes & Noble. For a moment, we danced, and Lincoln tipped me backwards. I trusted him, so I dipped; I trusted John Loengard, so I gave up any pretense that I could determine what photograph he came up with. What do I see, now? Three people in a photograph, one of them —in spite of not registering on film —pleased and maybe even applauding, because you have only to look at Loengard's photographs of his family to know how capable of love he is. The house is sold, but until the day I left I often thought of him, unexpectedly. Other photographers had photographed me there, but there was something so kinetic in the connection between the three of us that day, only Loengard lingered.

It interests me, sometimes, to read the footnotes before the main text, to flip to the back of James Wright's collected poems and read the index of first lines listed alphabetically, rather than to read the actual poems. What you sometimes see with footnotes is a changed tone of voice that reveals something about the author you wouldn't know from the text, such as a sense of humor; with Wright, a dozen first lines, or 20, compose

a found poem. Read John Loengard's brief descriptions of his photographs, and you'll be overwhelmed by a humane quality you'd never expect in a factual account. Any novelist could look at the text, without the photographs, and have a good idea about where to start the novel about Loengard. It would have to express a sense of the world that is always curious, but never churlish. The dry sense of humor would be important. The humility. The sheer quality of the vision. And then you would have to bring in the minor characters, all at this moment left abstract: the snow; the light; the trees; the cat on the fence; the breeze—all things of the natural world, which cradle his vision.

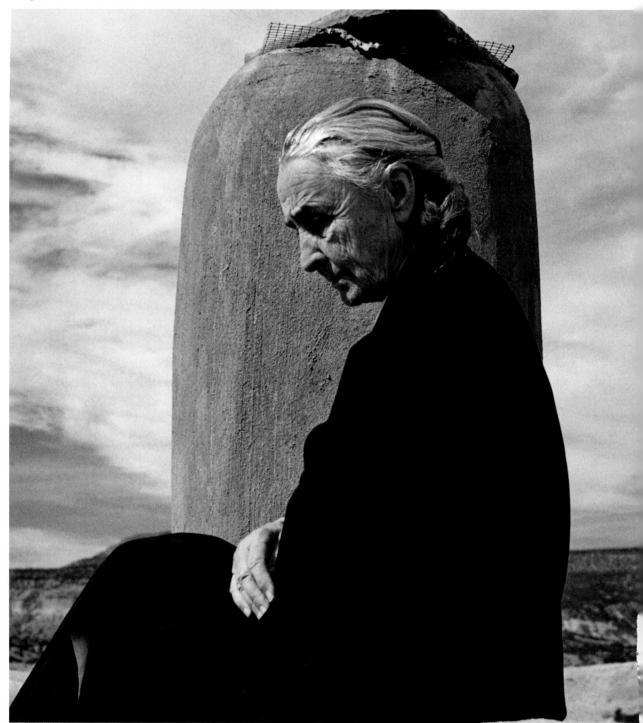

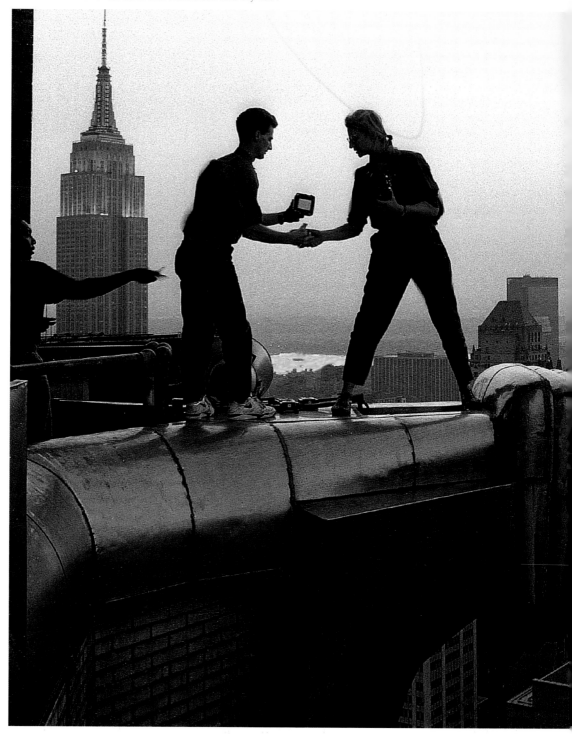

Ann Beattie and Lincoln Perry. Charlottesville, Virginia. 1990

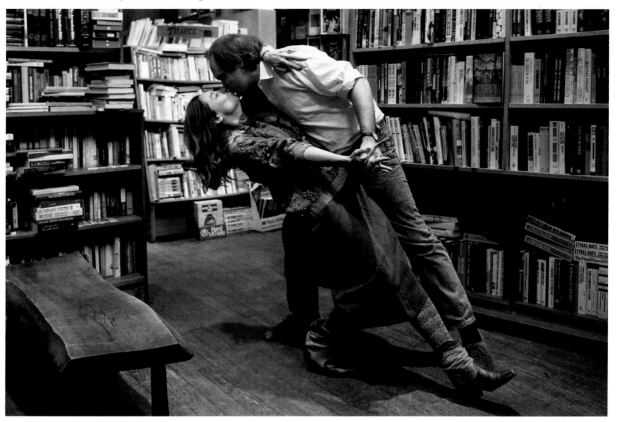

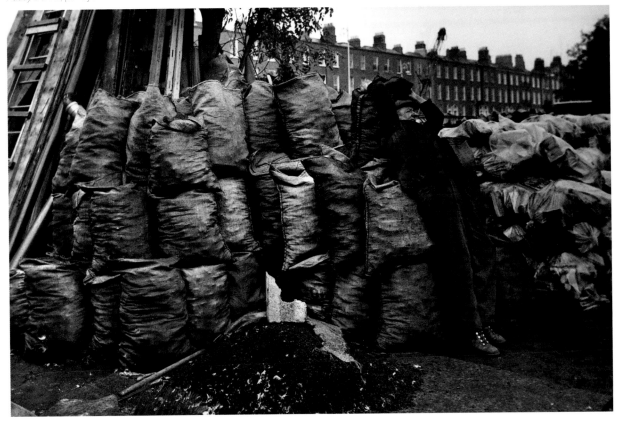

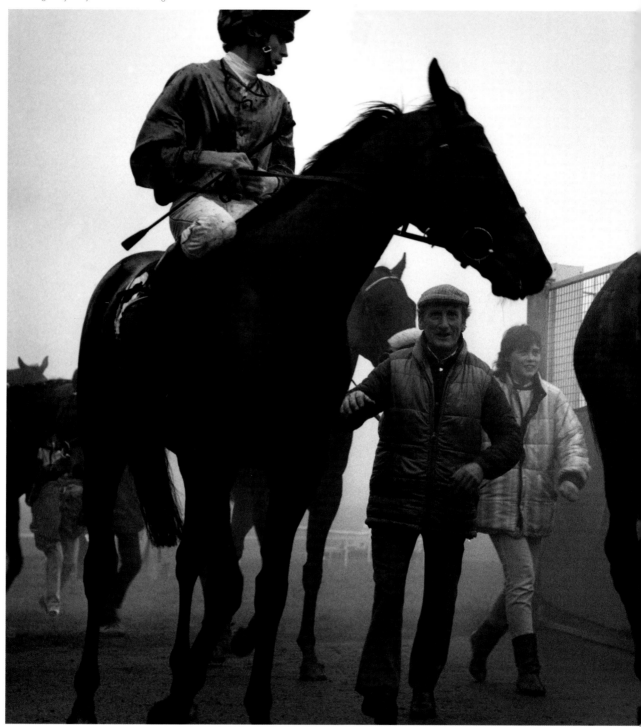

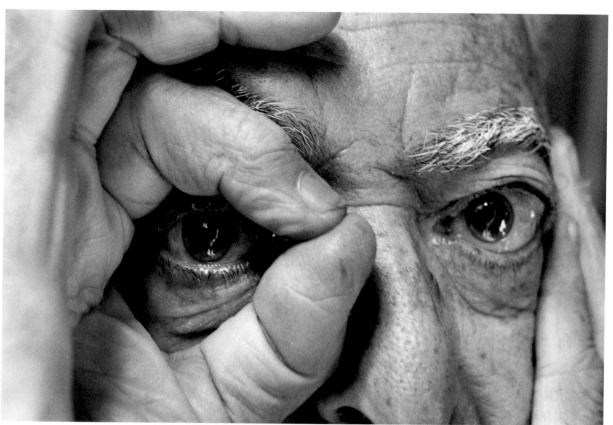

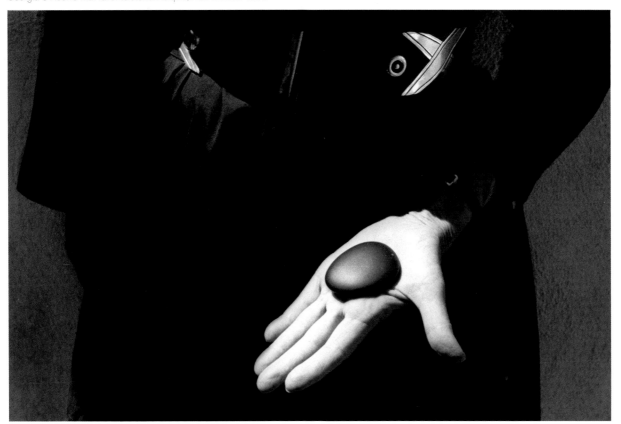

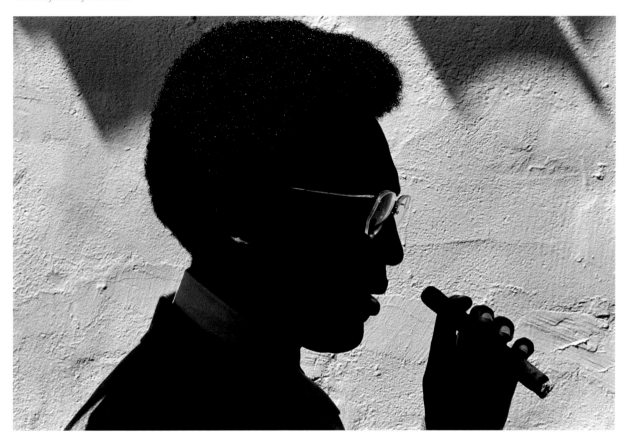

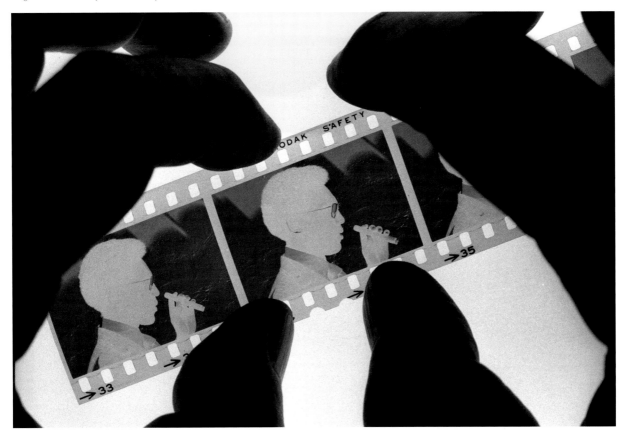

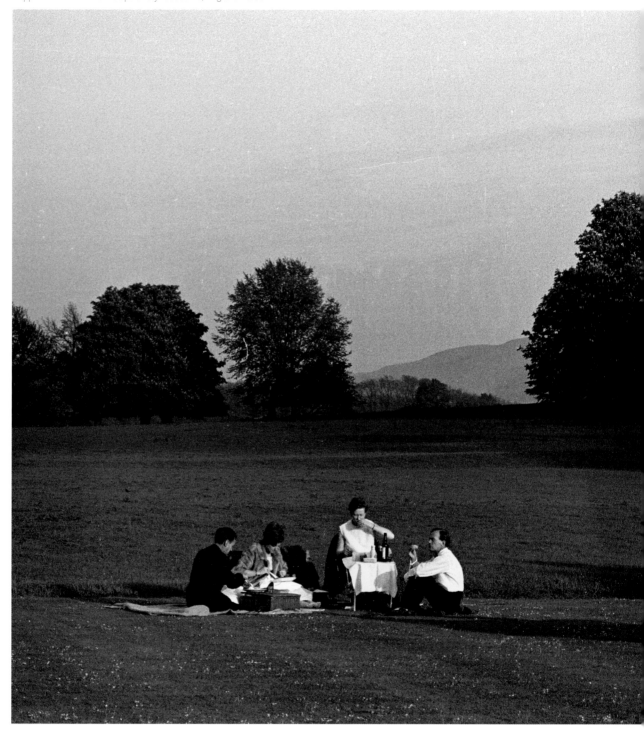

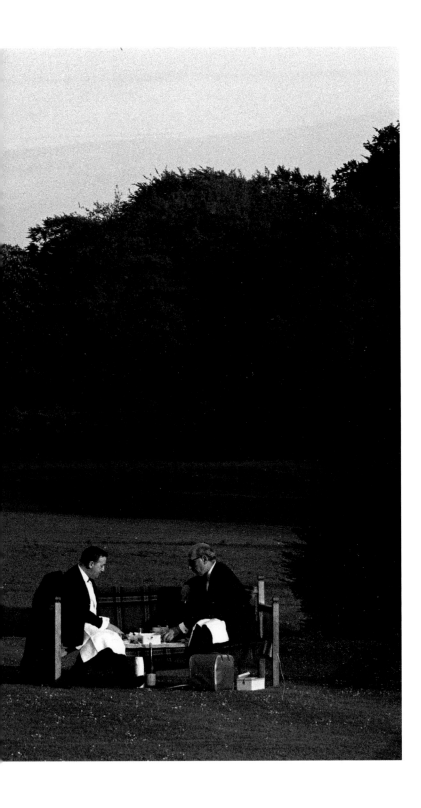

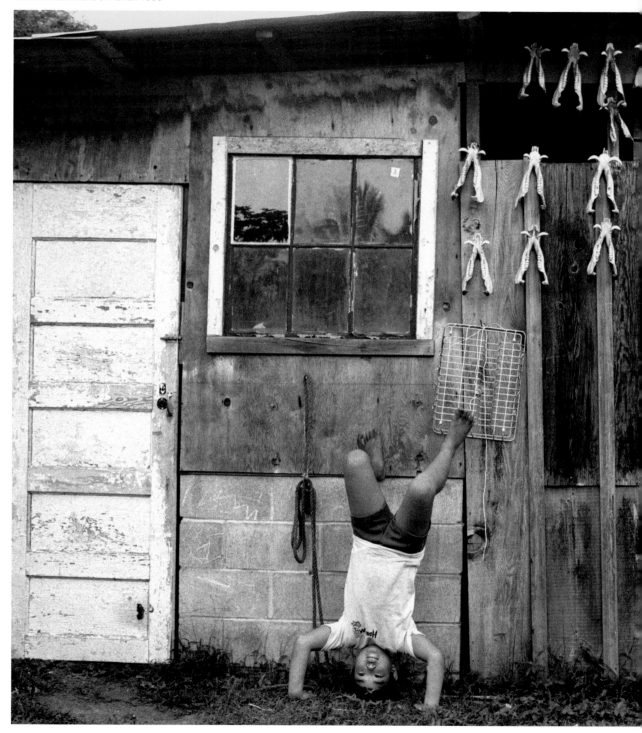

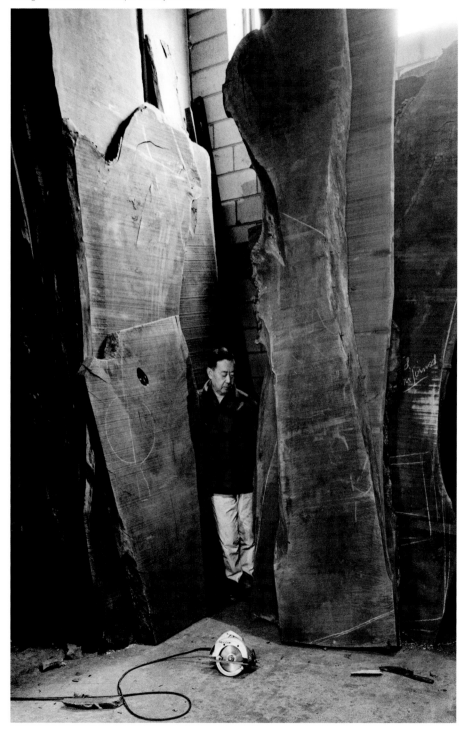

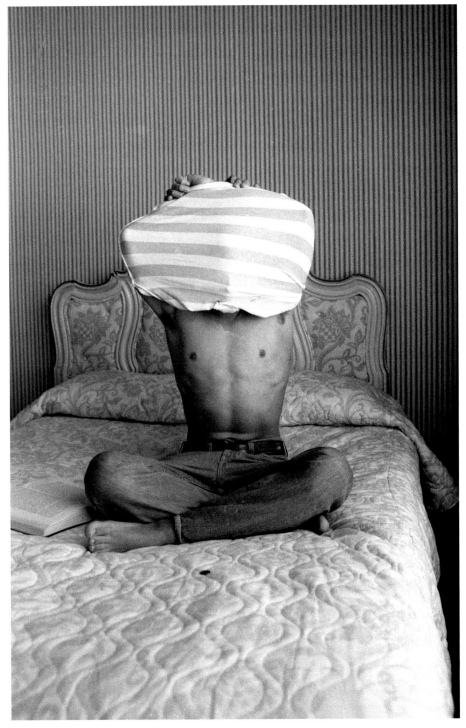

Identical twins David and Peter Turnley. Paris. 1989

Doheny & Nesbitts Pub. Dublin. 1987

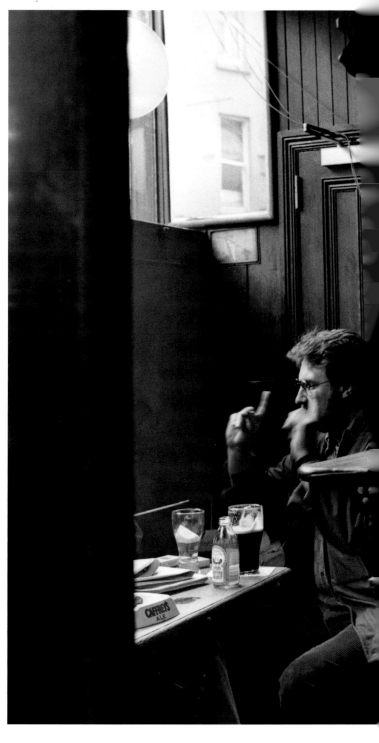

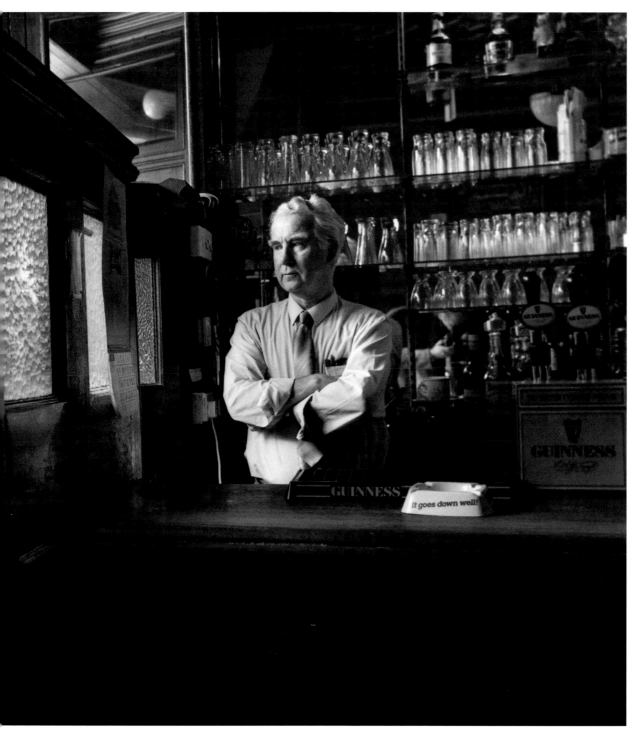

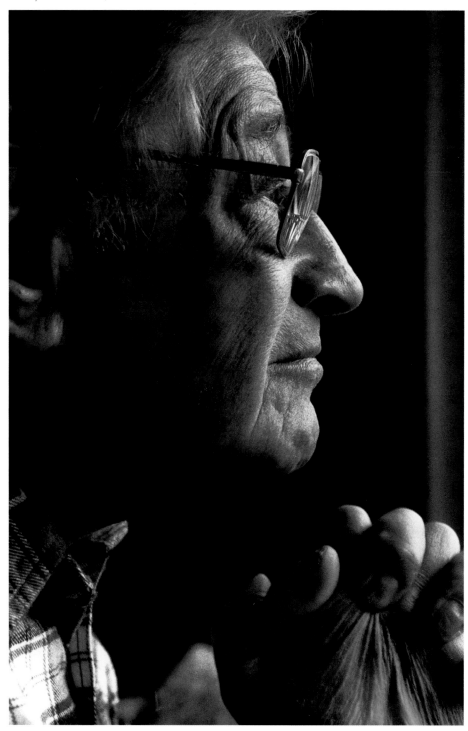

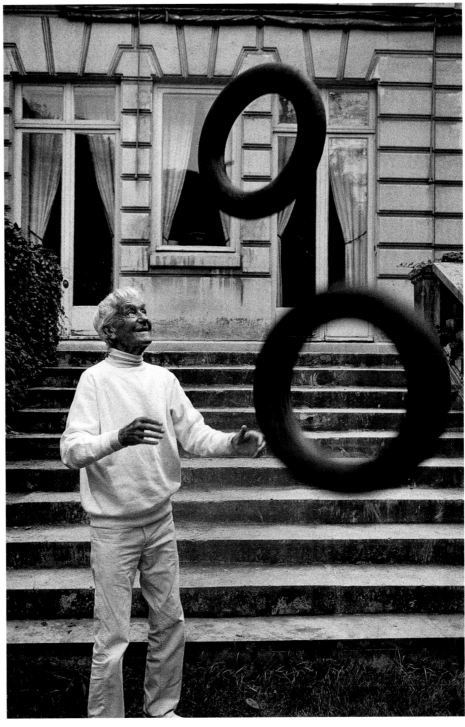

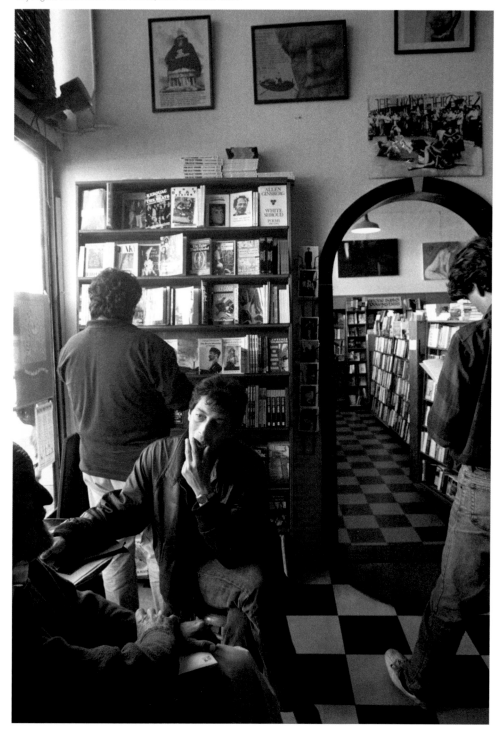

Café Vesuvio. North Beach, San Francisco. 1990

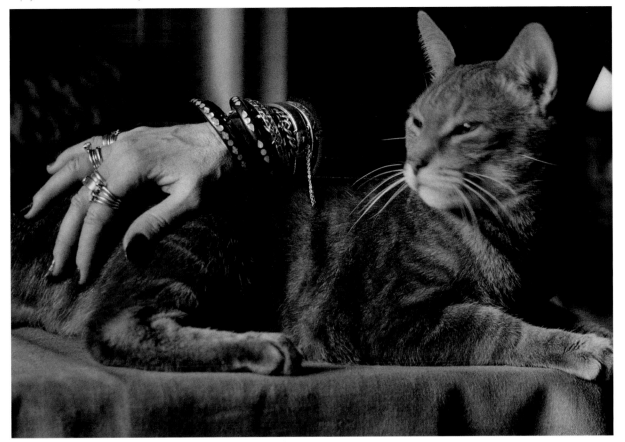

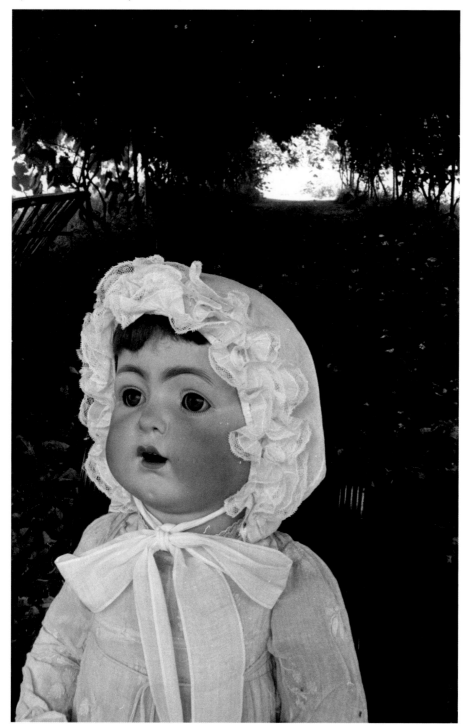

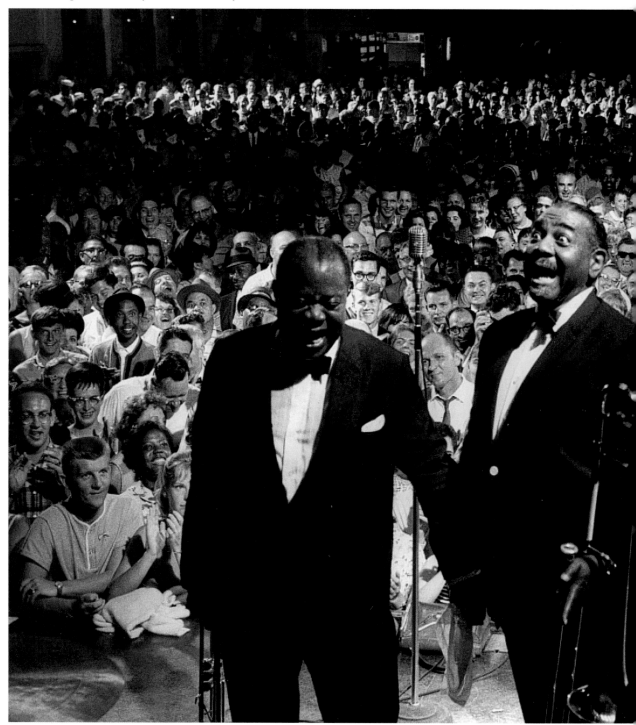

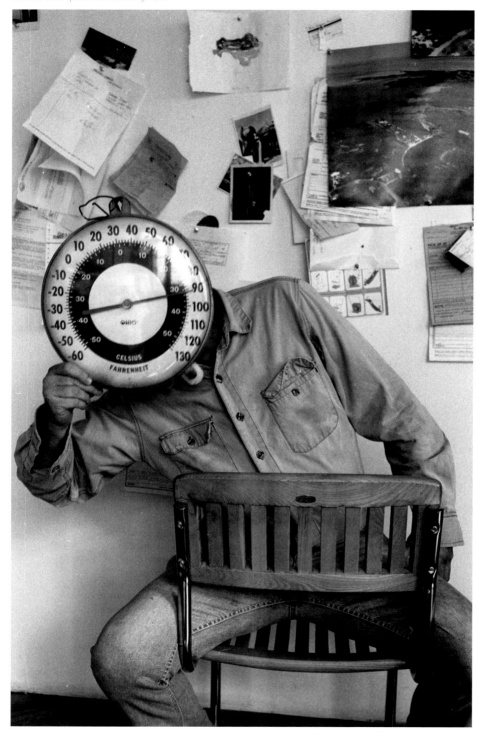

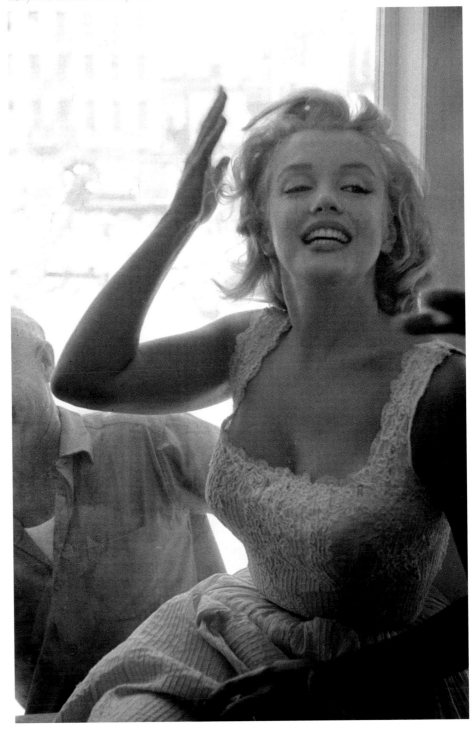

Ronald Reagan. Fresno, California. 1966

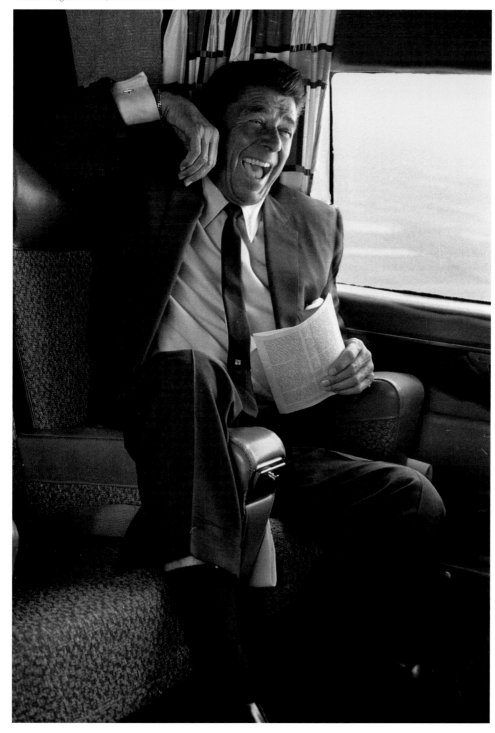

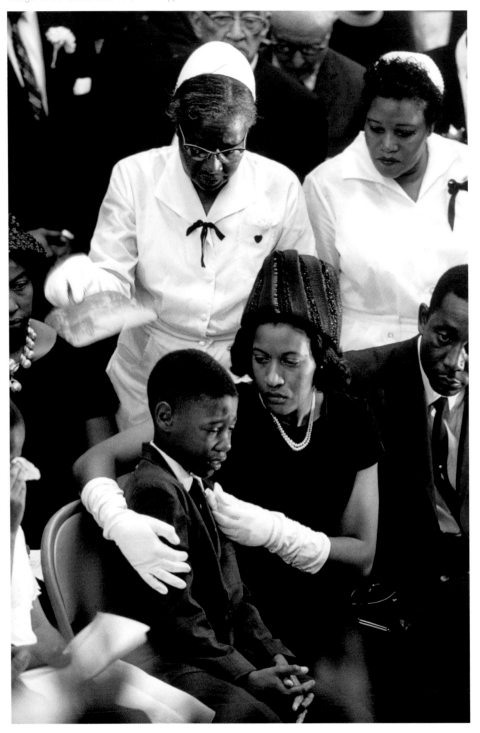

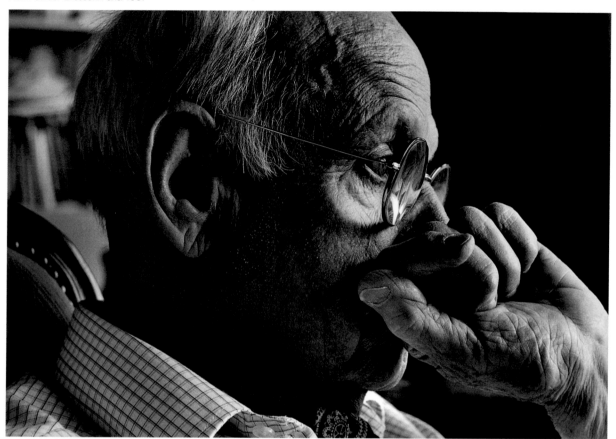

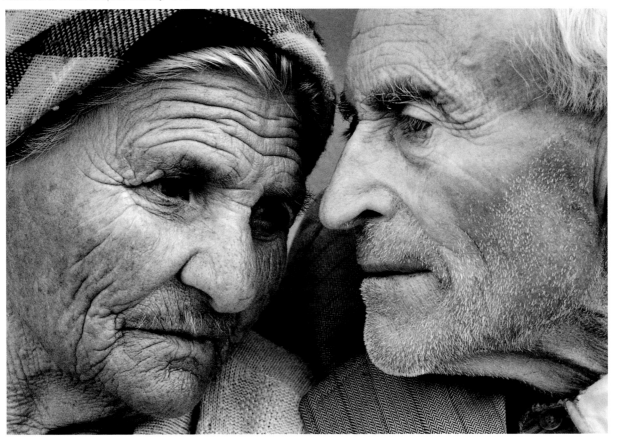

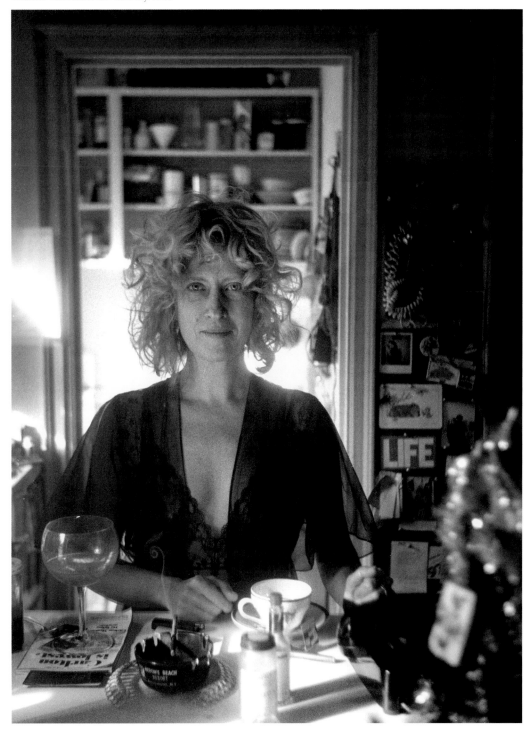

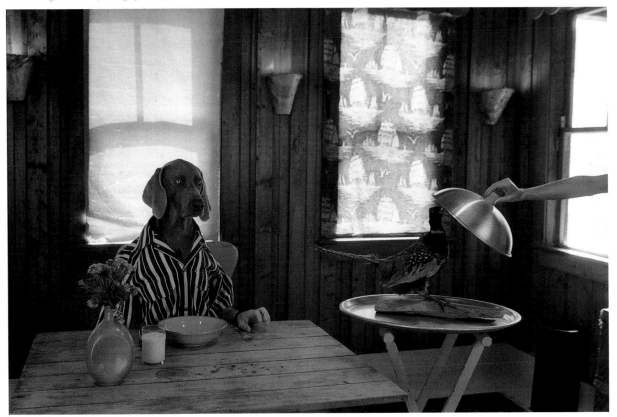

Edward Kennedy arrives for Mary Jo Kopechne's funeral. Plymouth, Pennsylvania. 1969

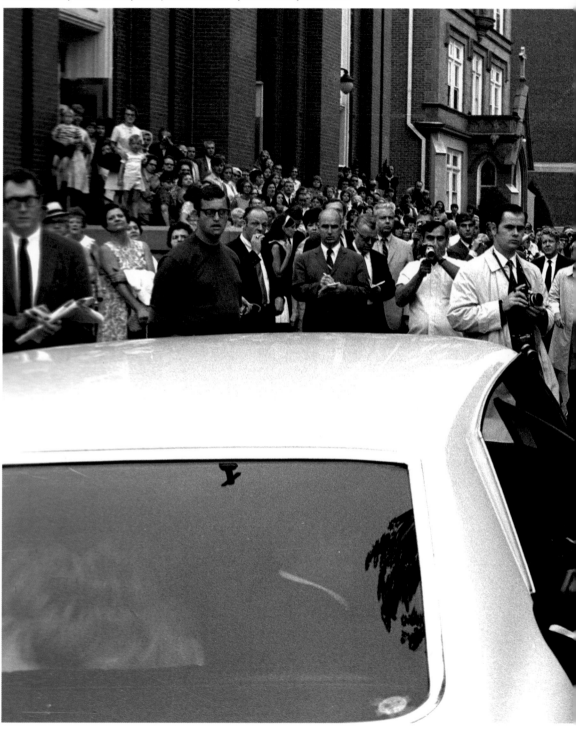

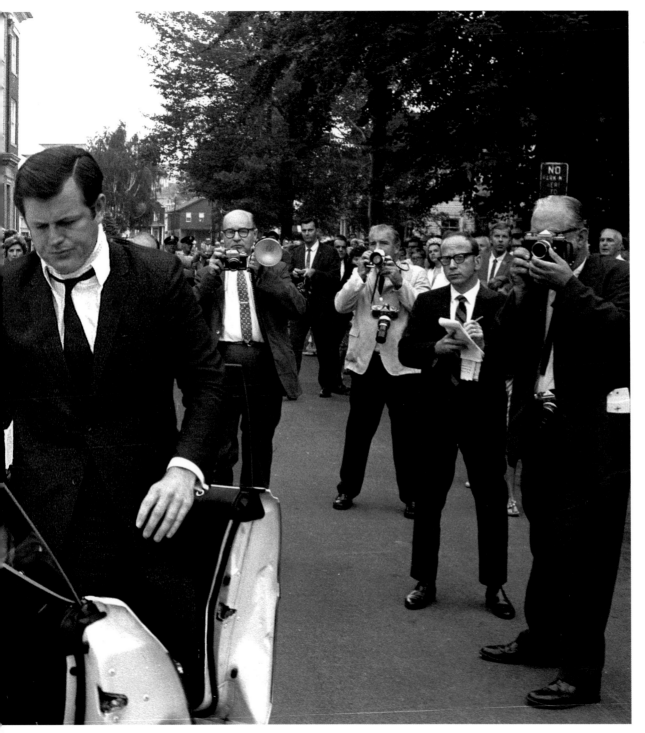

61

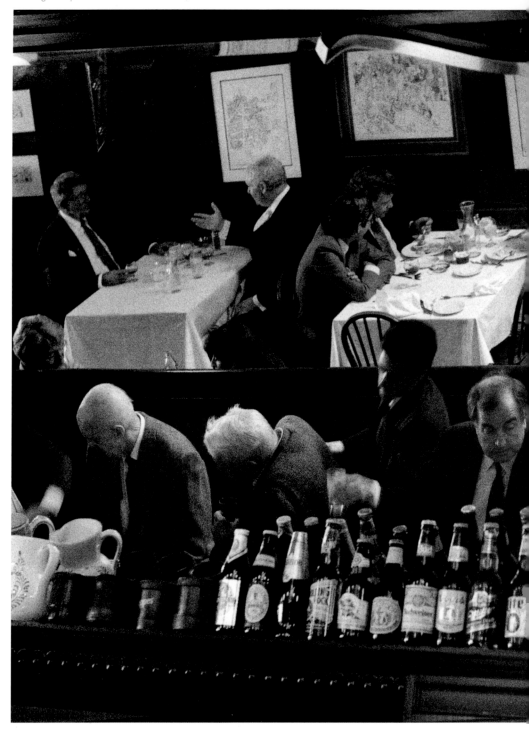

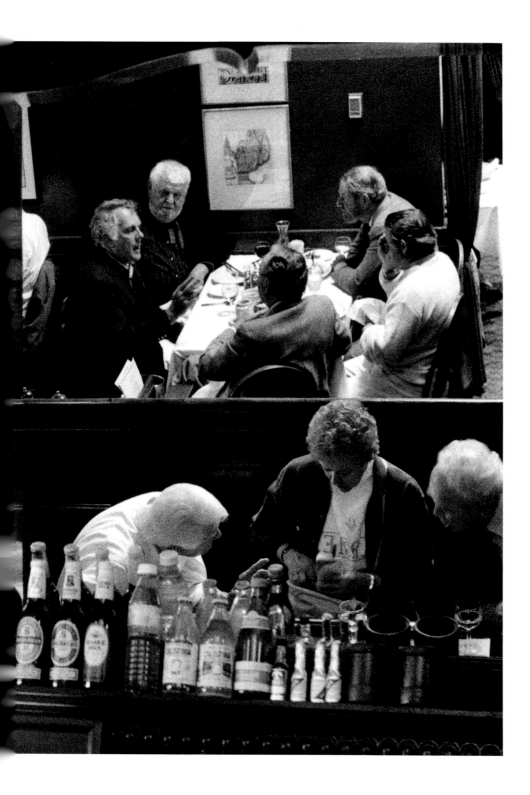

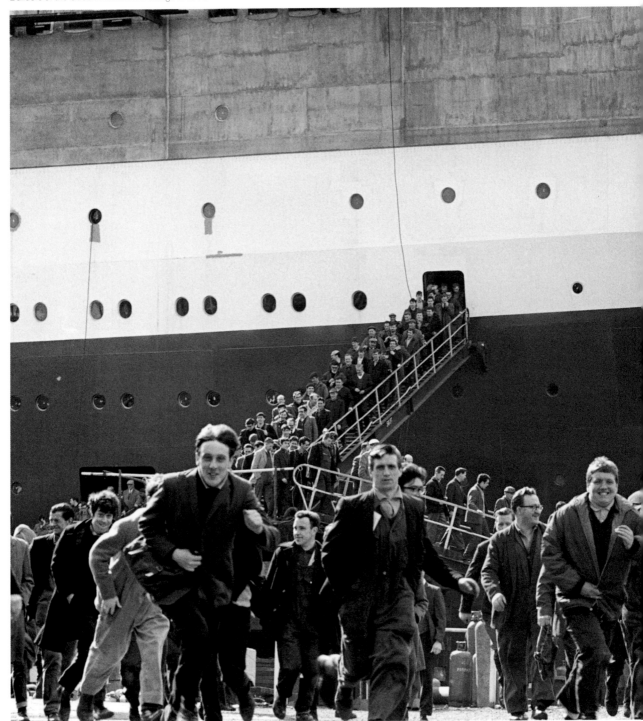

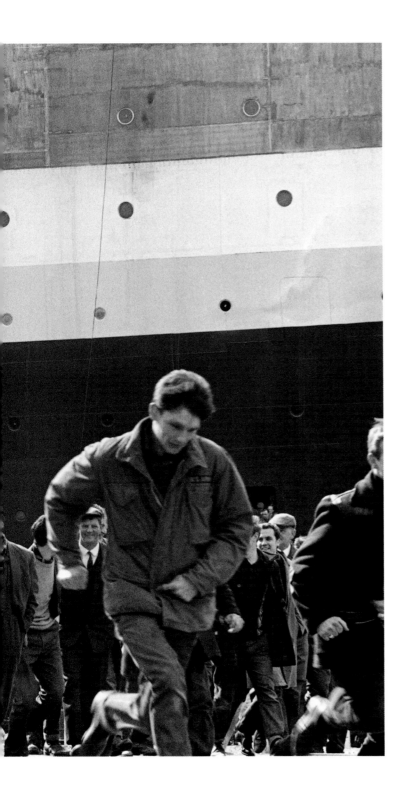

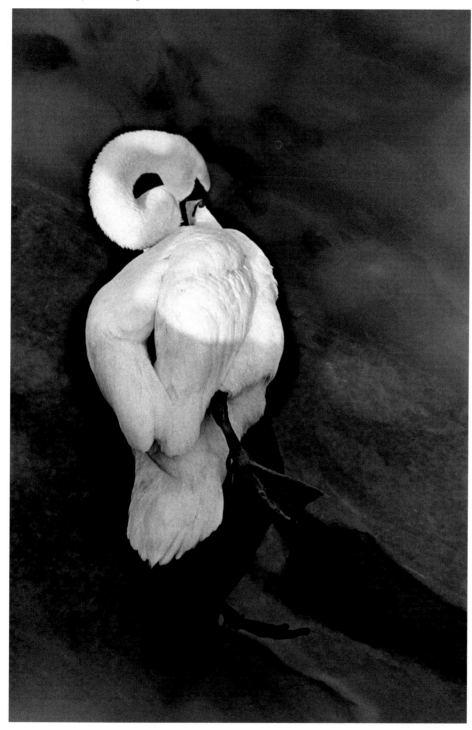

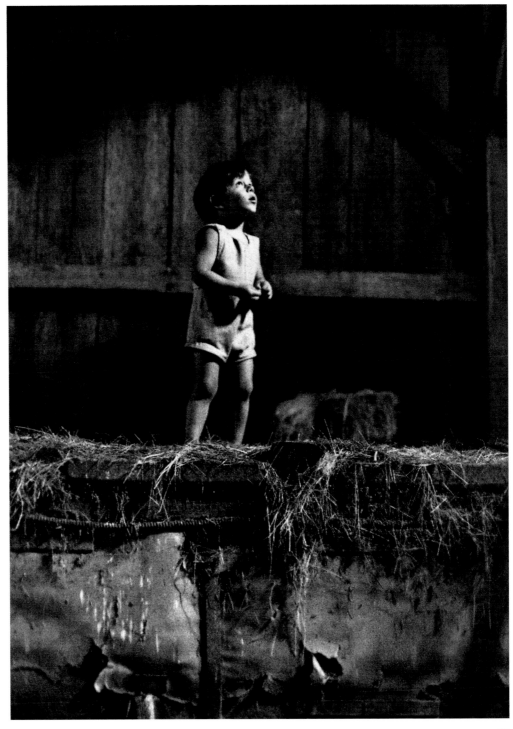

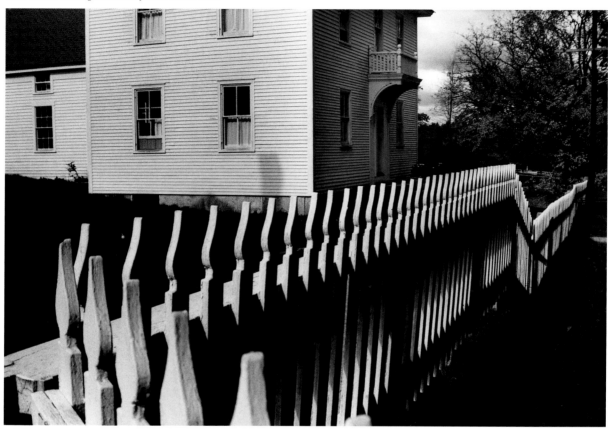

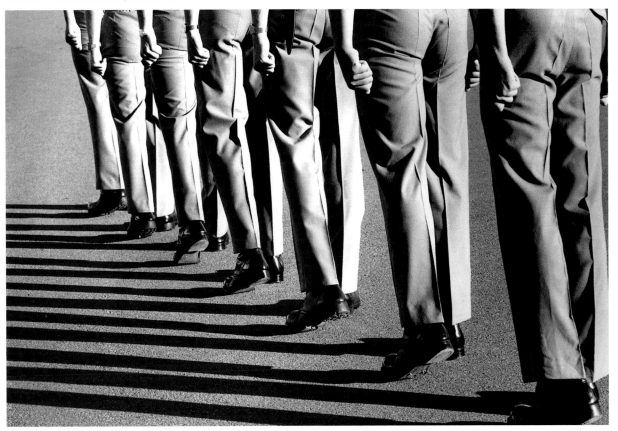

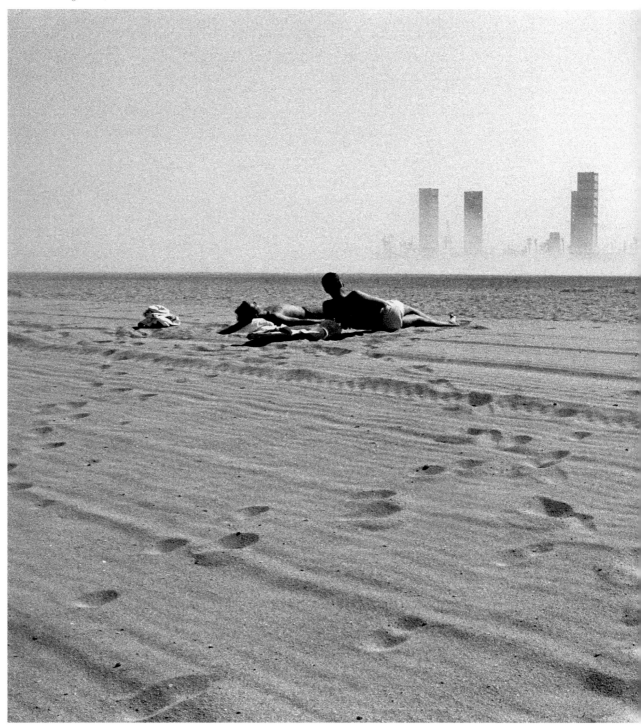

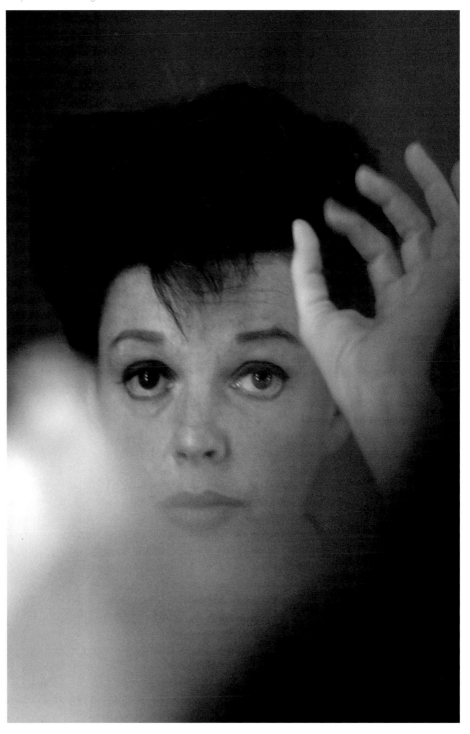

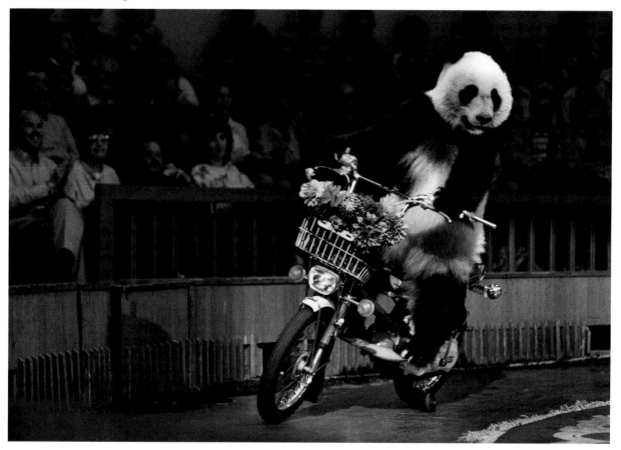

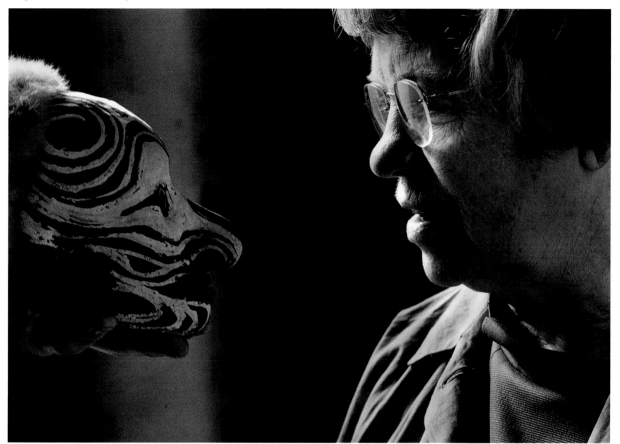

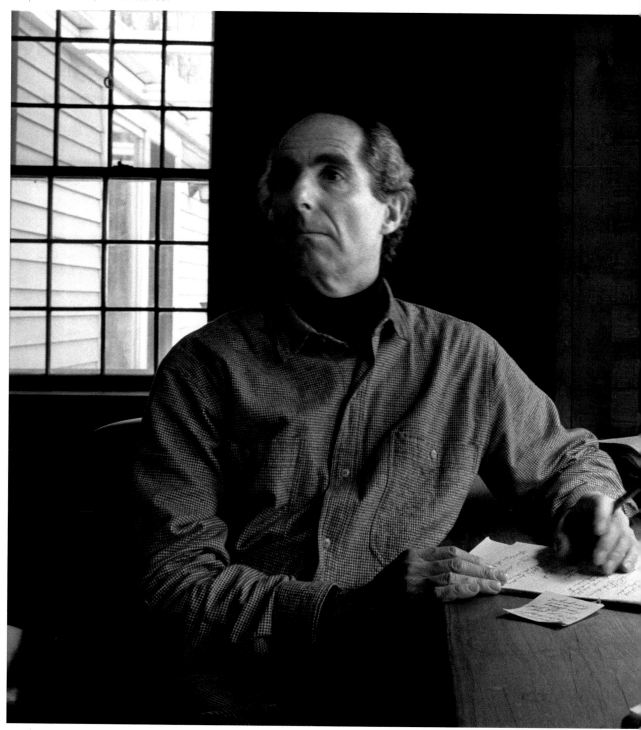

Philip Roth. Cornwall, Connecticut. 1991

John Updike. Beverly Farms, Massachusetts. 1999

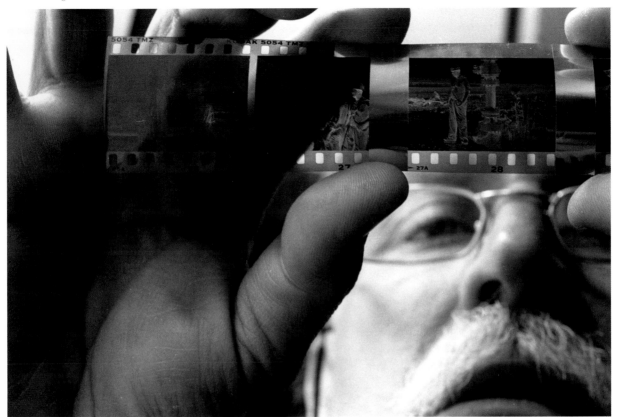

John Byrna, groundskeeper, St. Martin's Green. Dublin. 1987

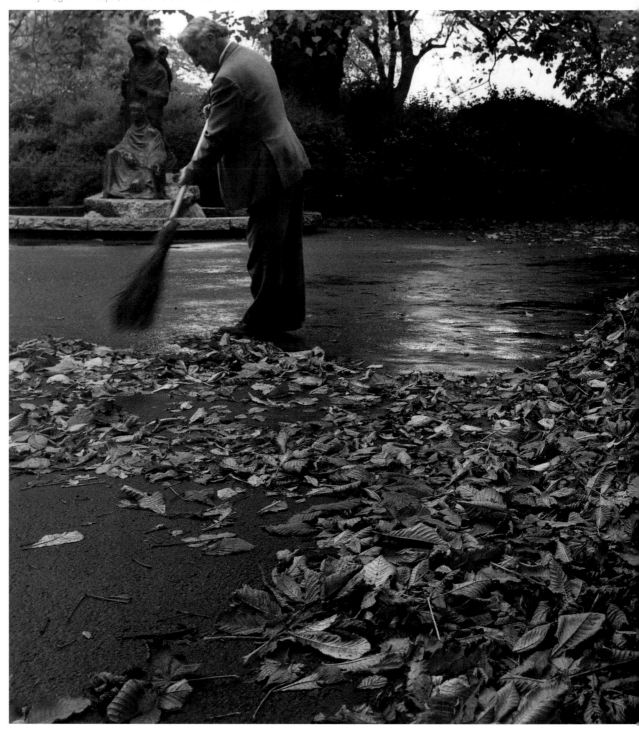

Hurricane-destroyed statue of Pierre le Moyne. Near Biloxi, Mississippi. 1970

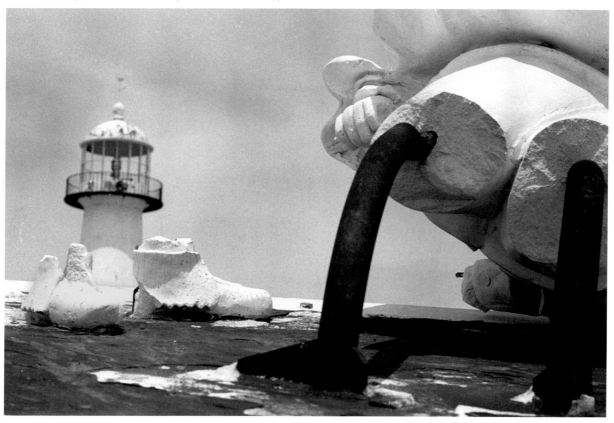

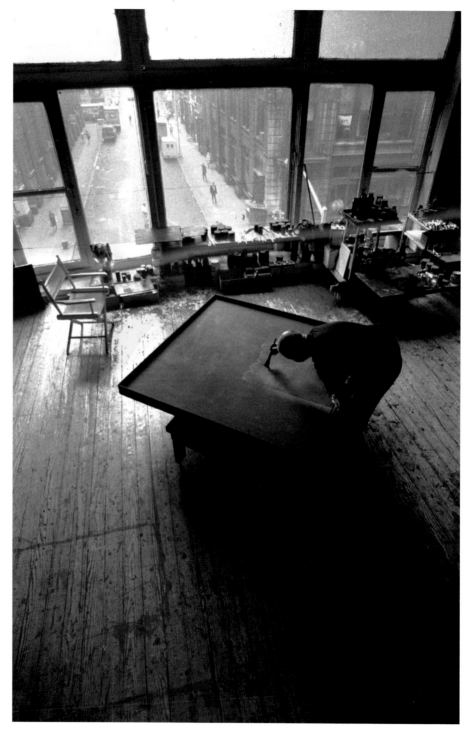

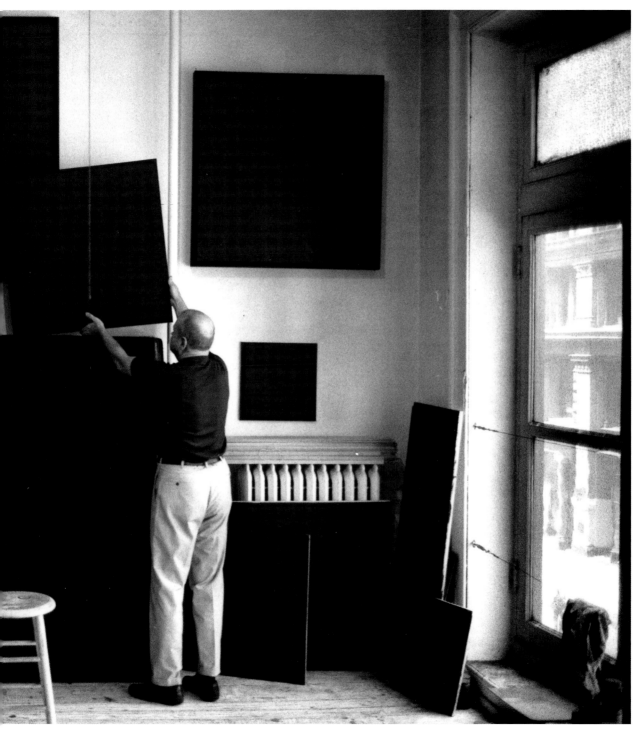

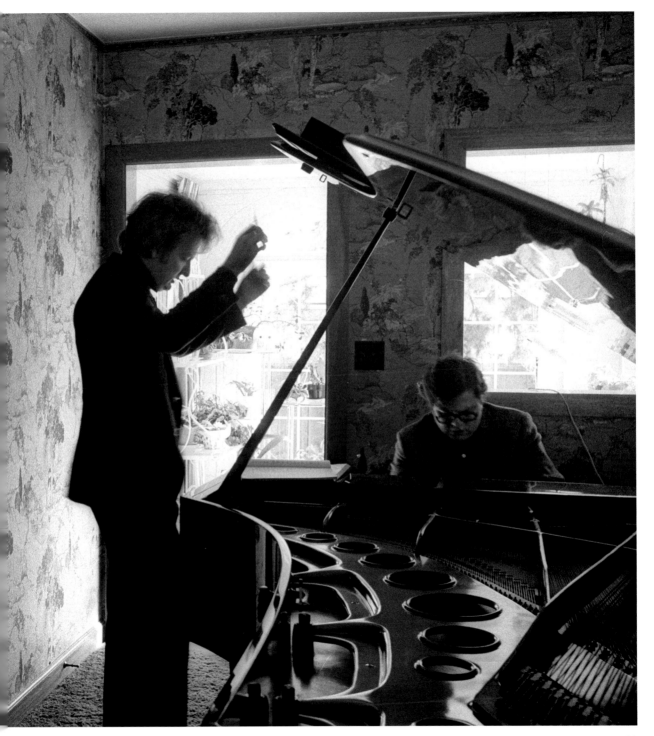

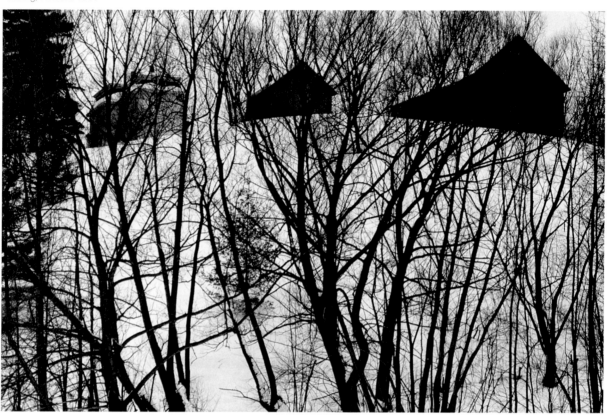

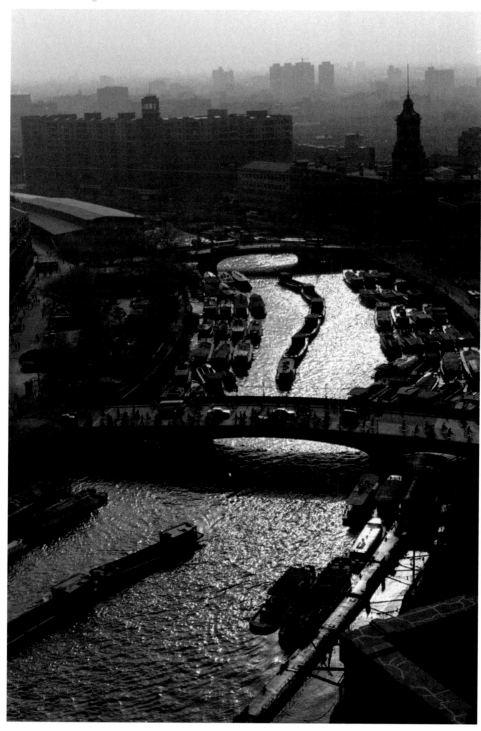

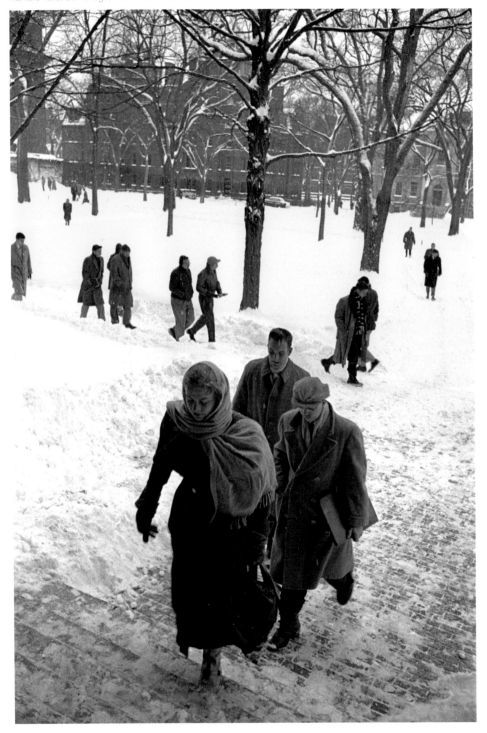

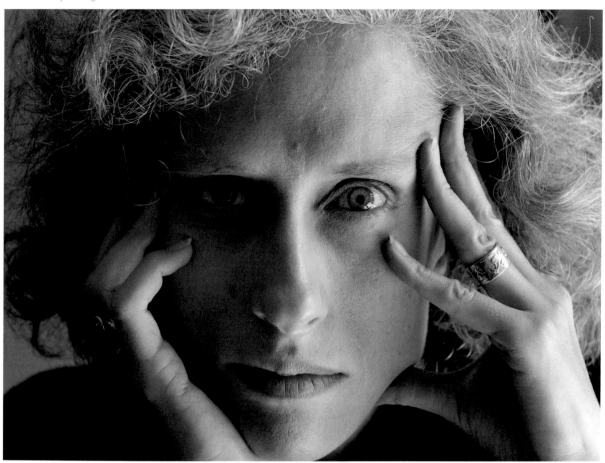

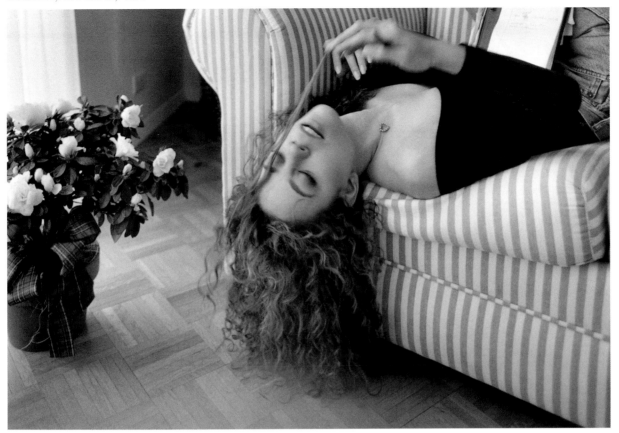

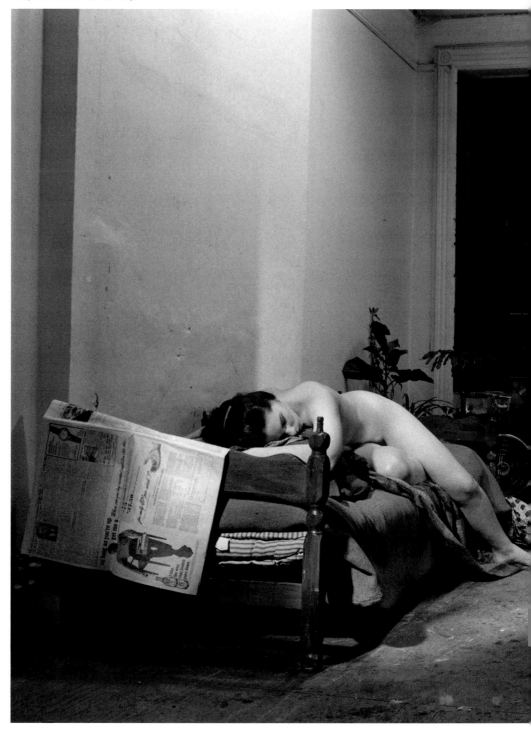

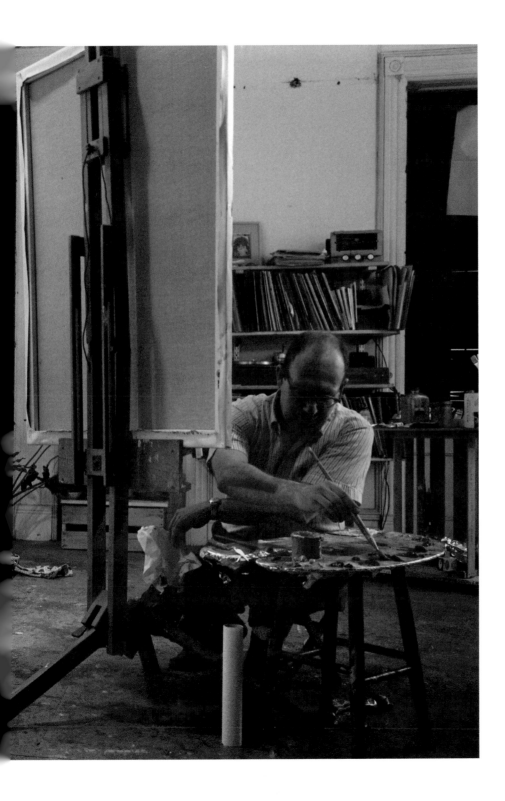

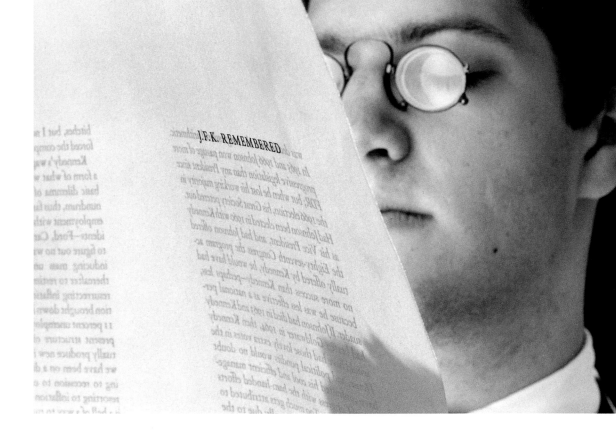

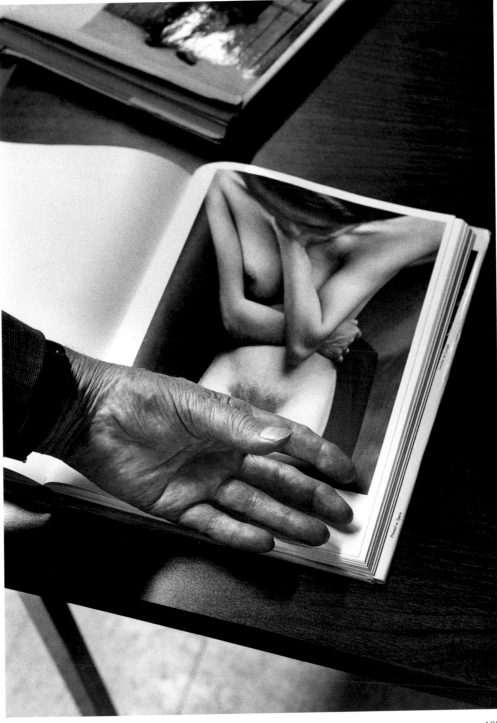

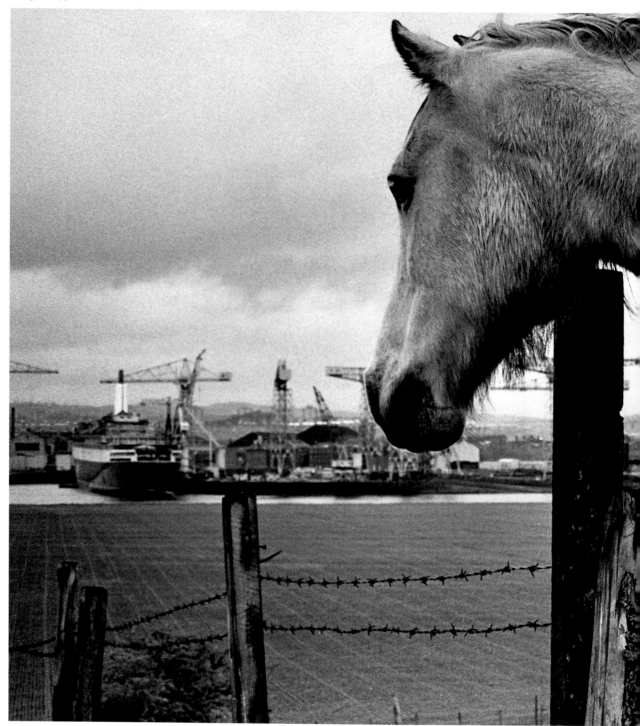

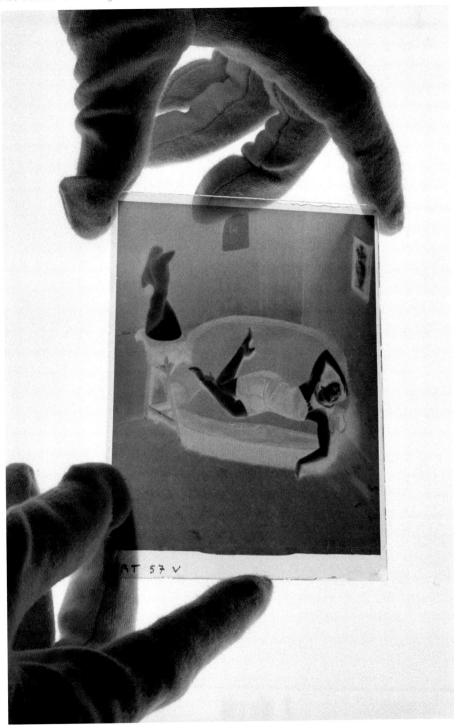

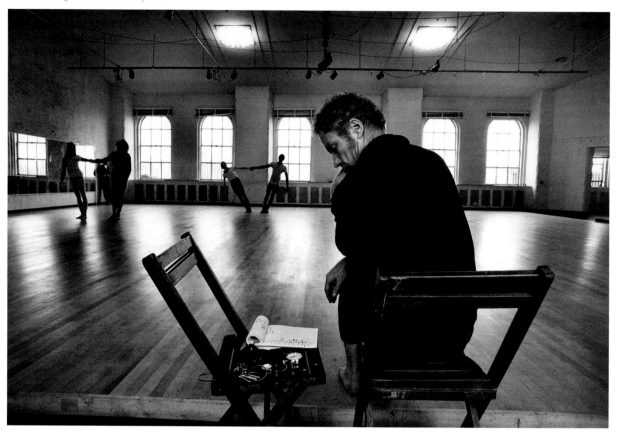

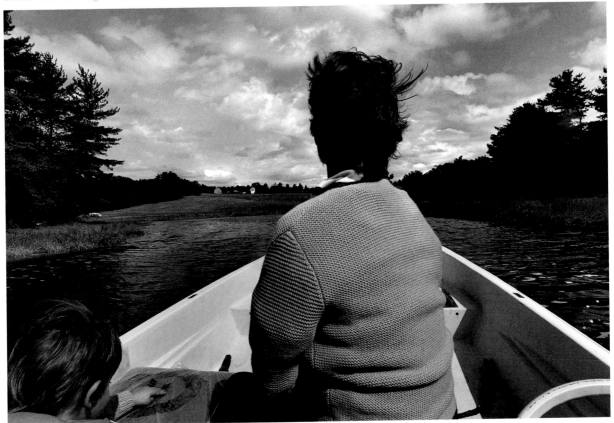

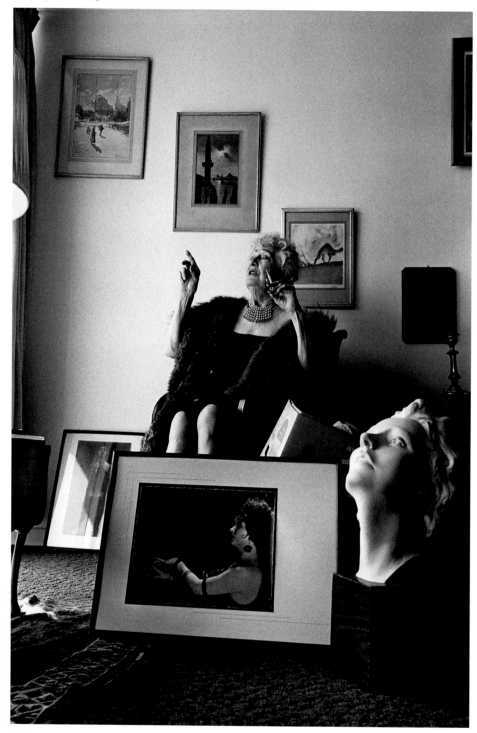

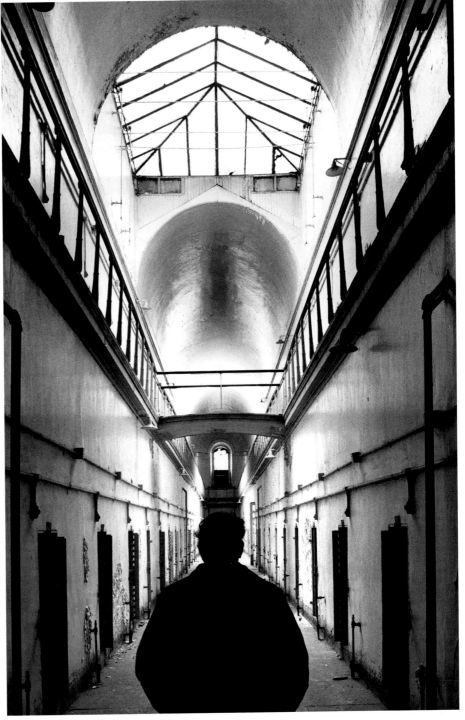

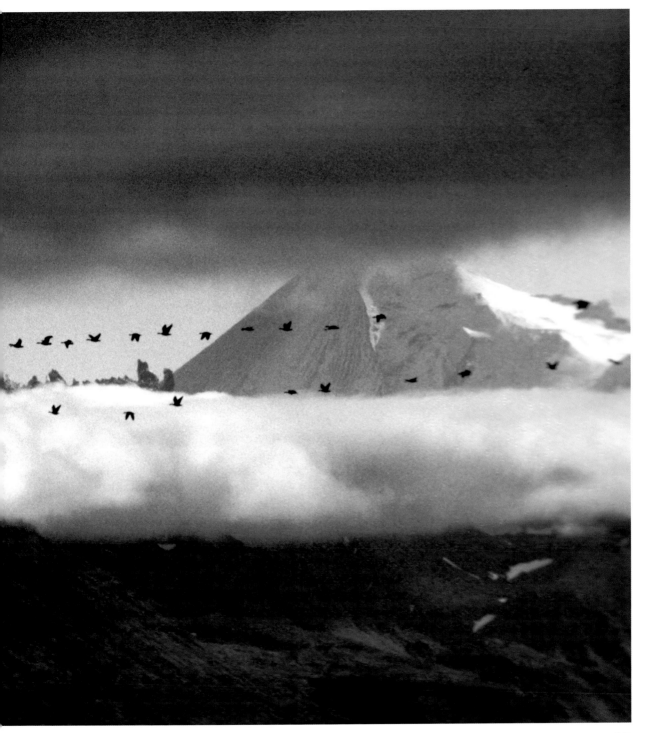

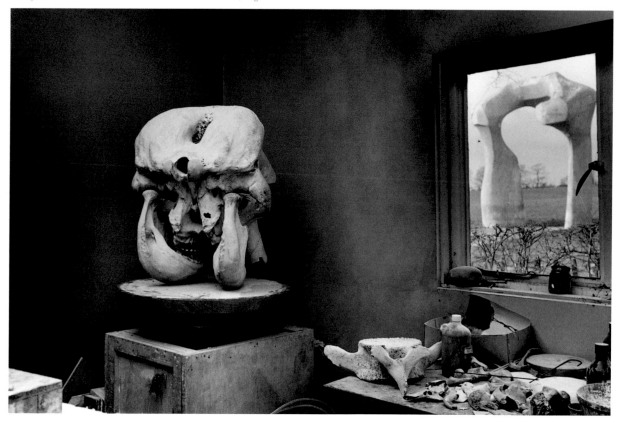

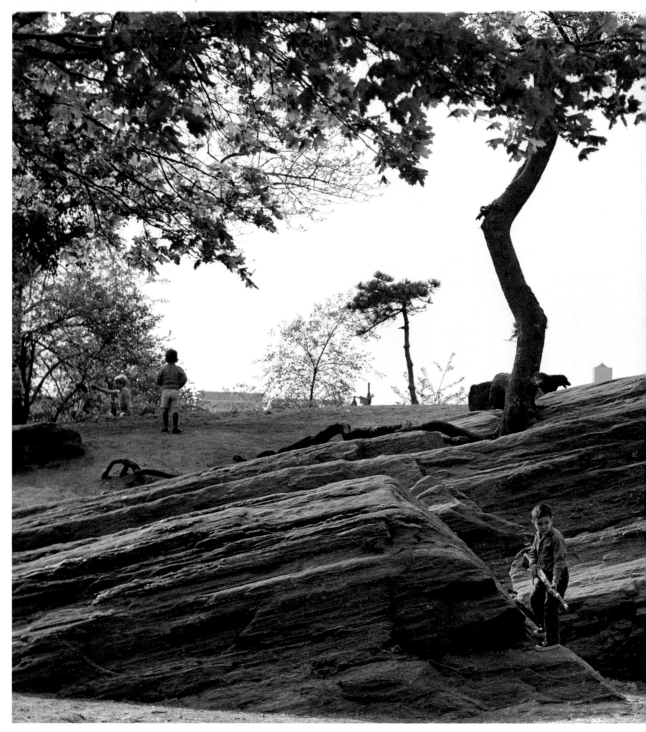

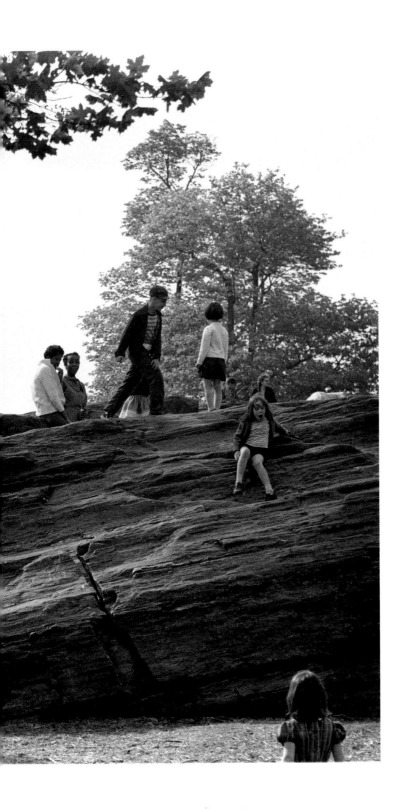

Princess Vera, great-granddaughter of Czar Nicholas I. Valley Cottage, New York. 1998

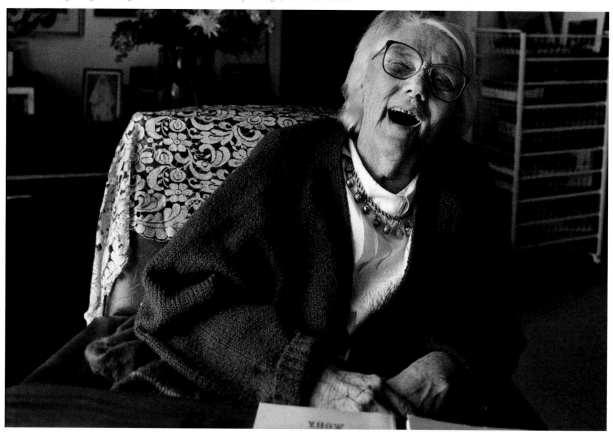

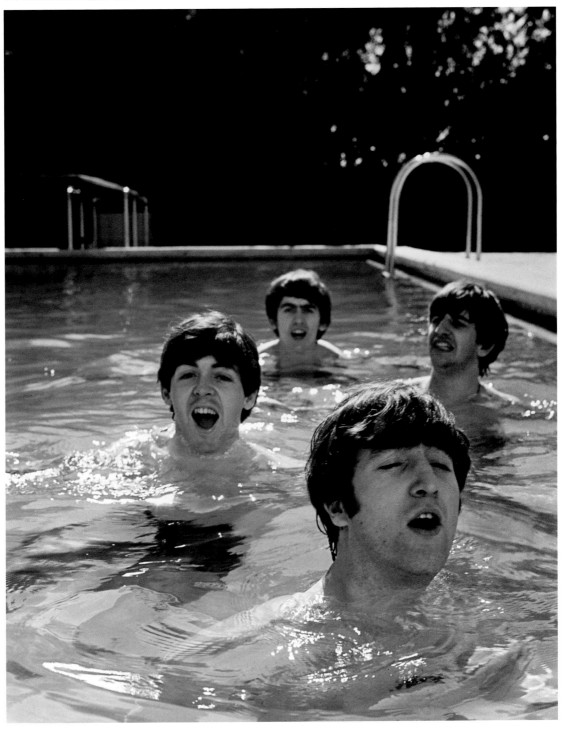

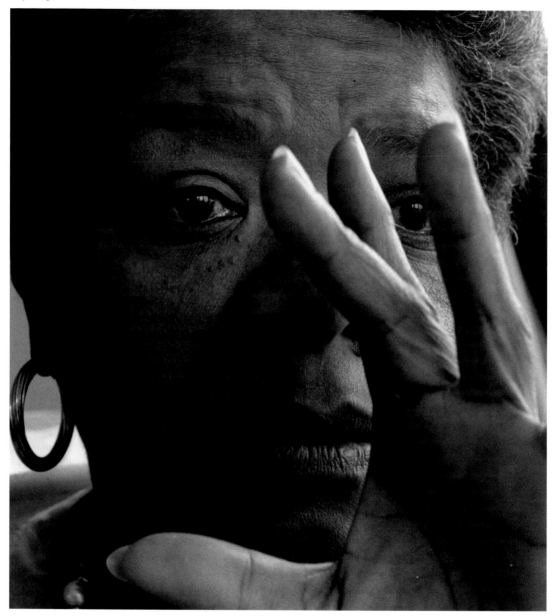

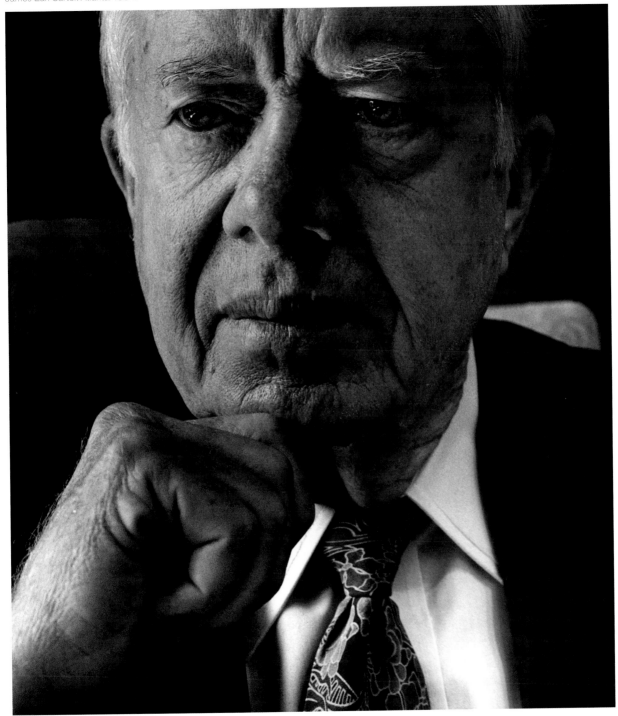

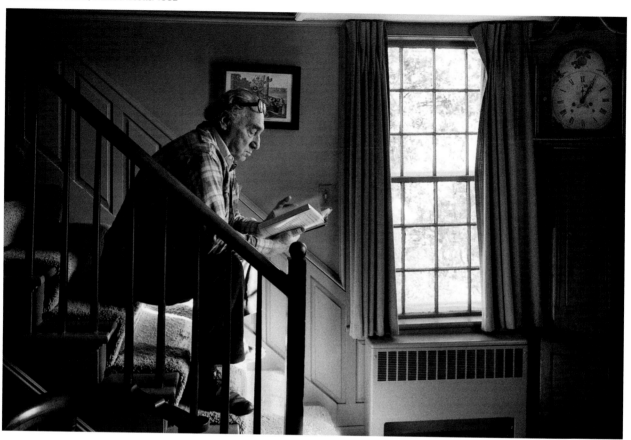

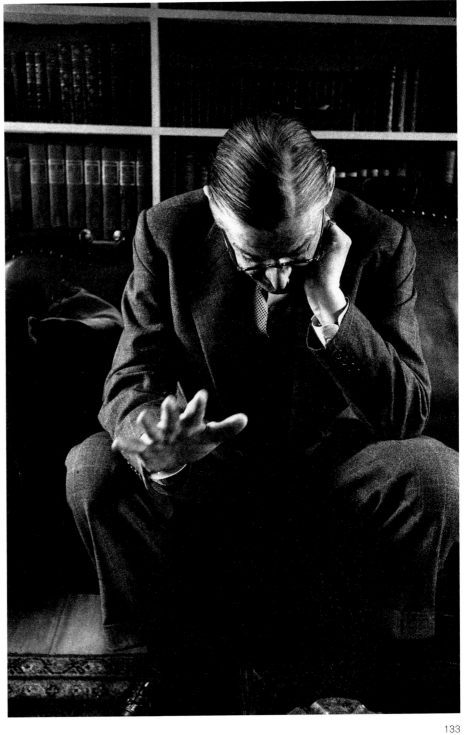

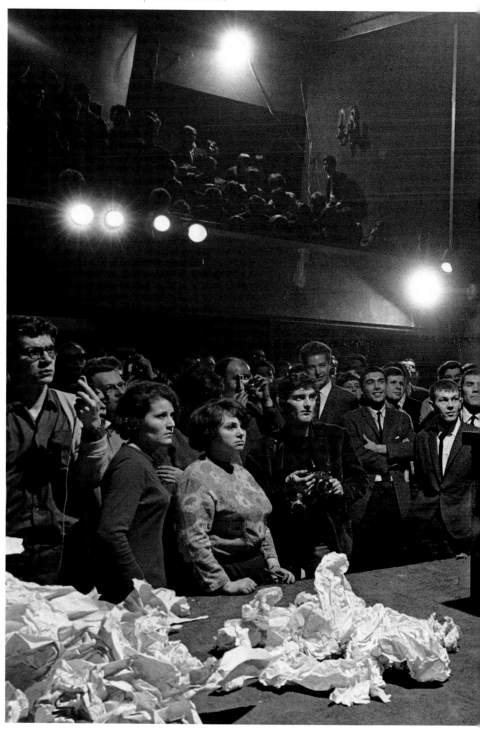

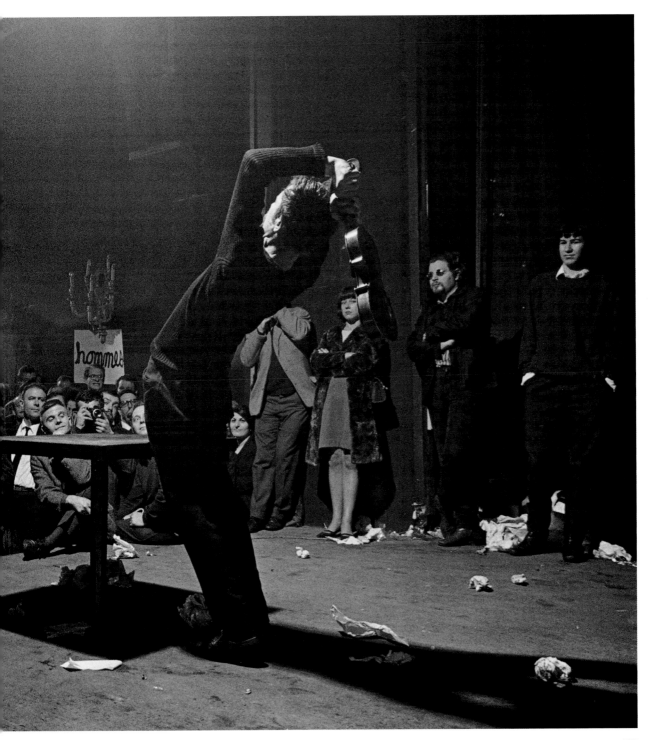

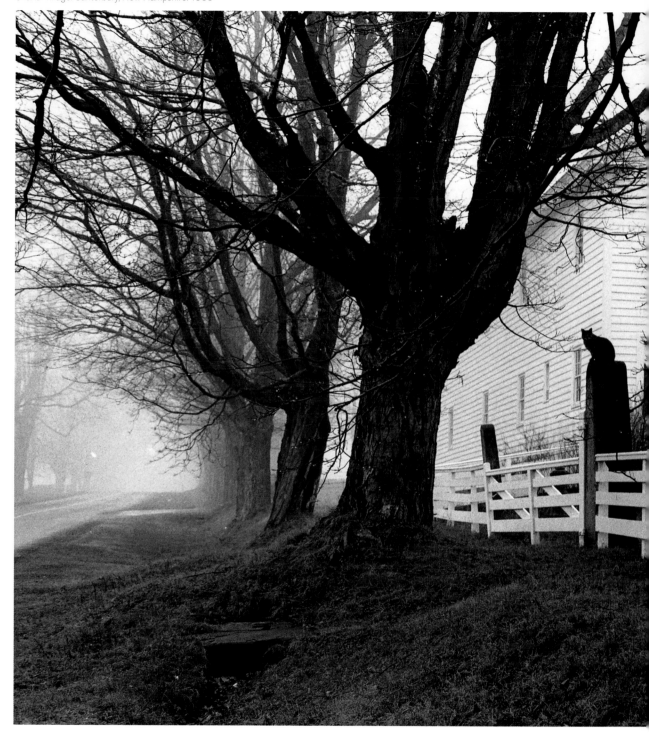

Quantity postcard shop. North Beach. San Francisco. 1990

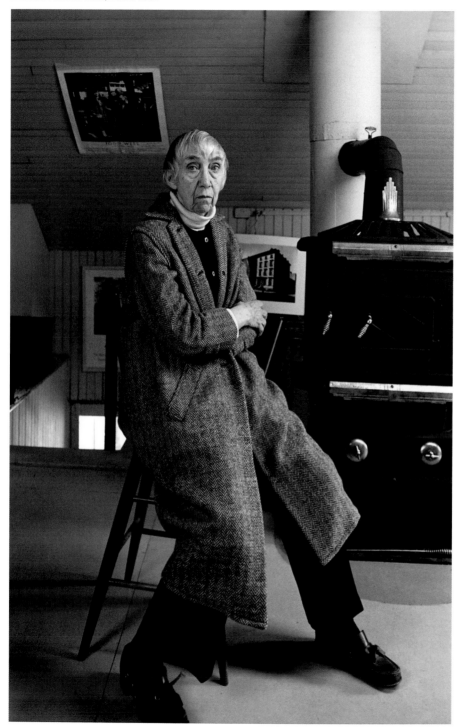

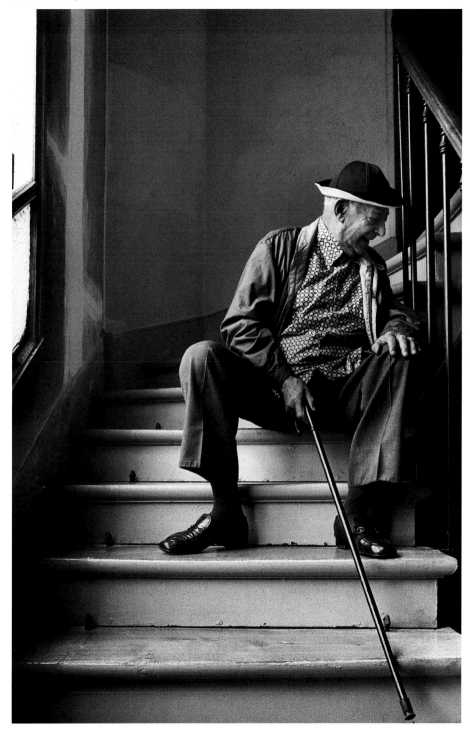

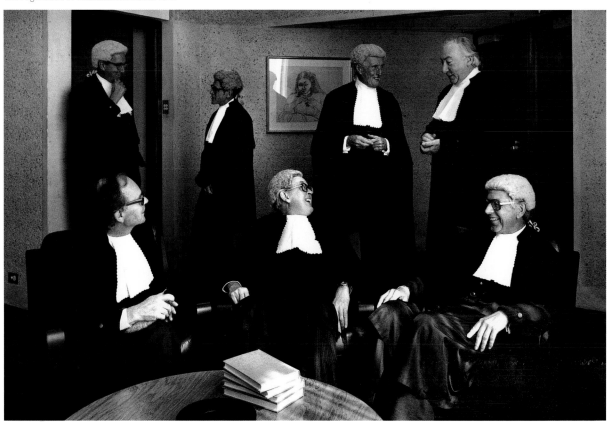

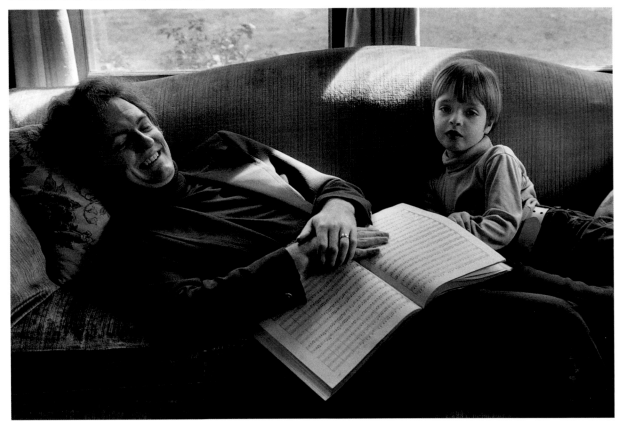

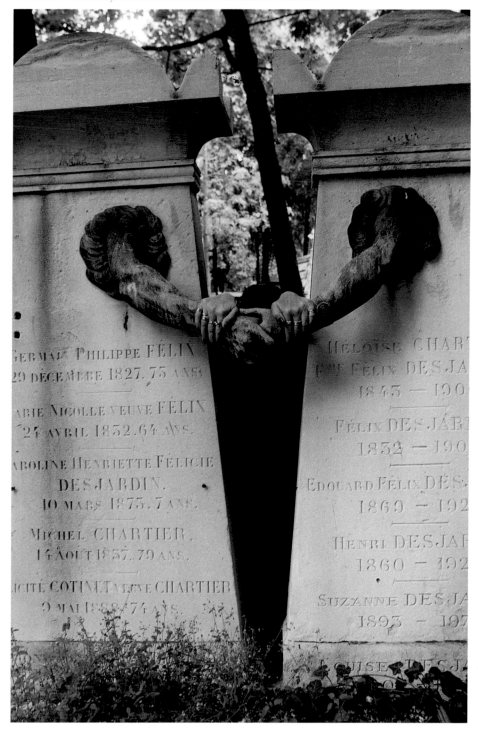

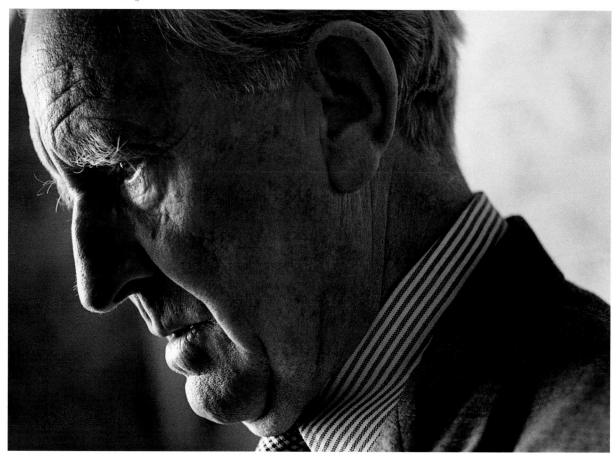

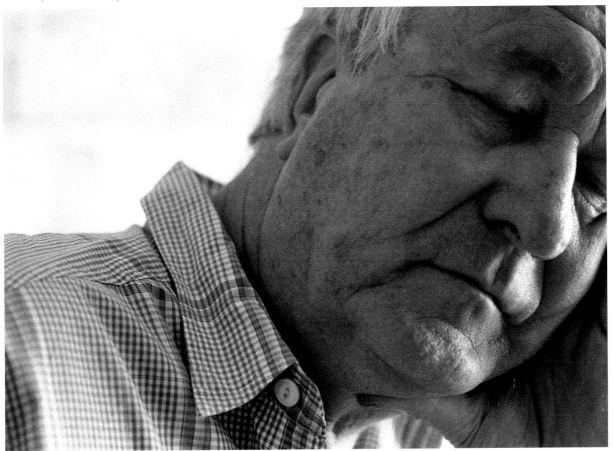

Beer delivery. Ottawa. 1984

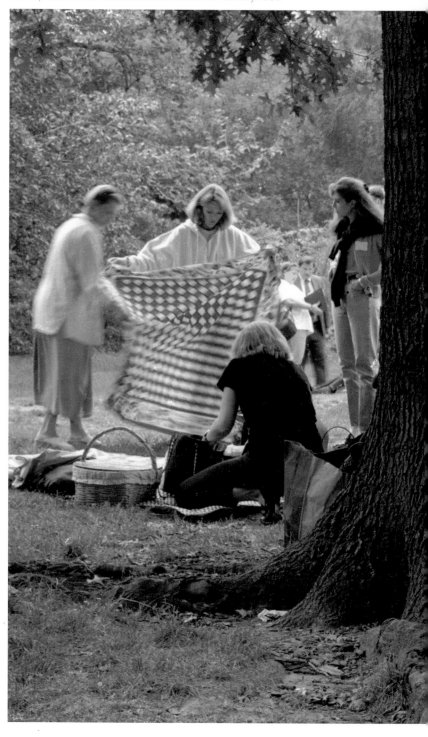

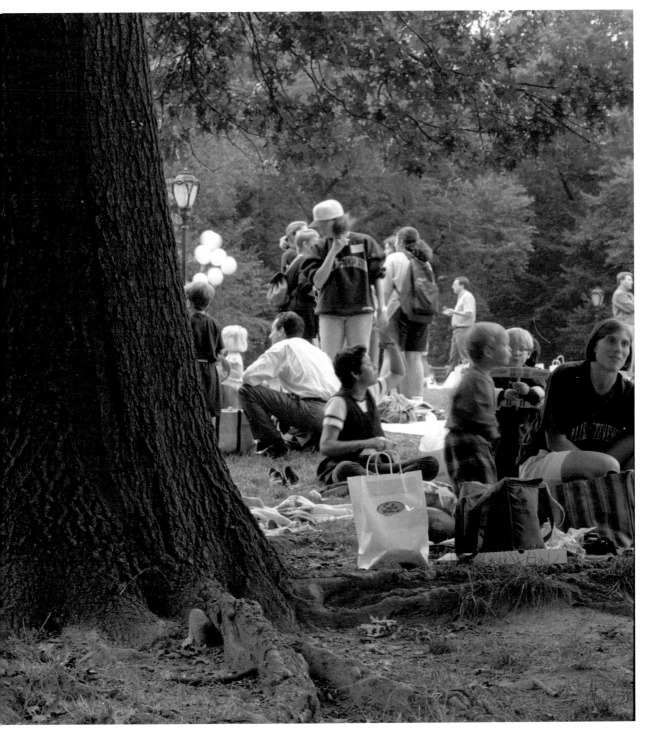

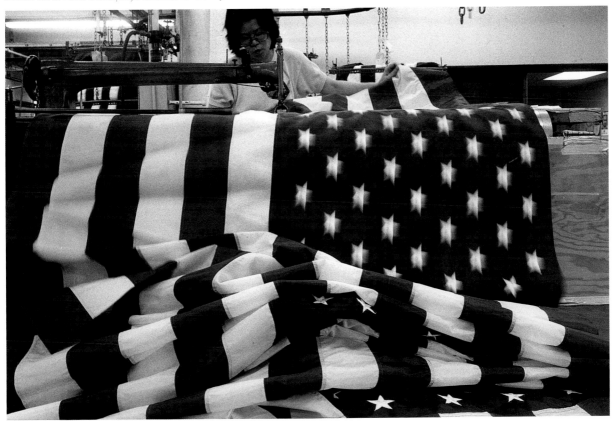

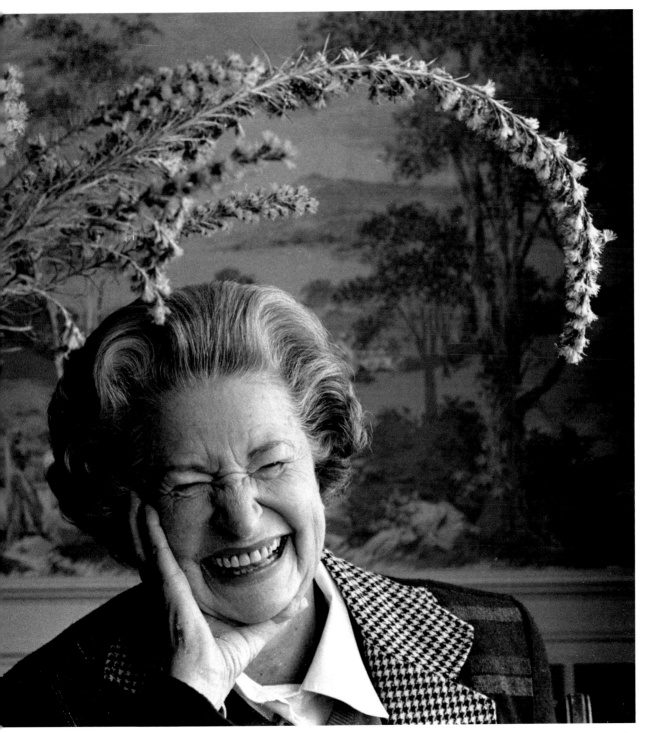

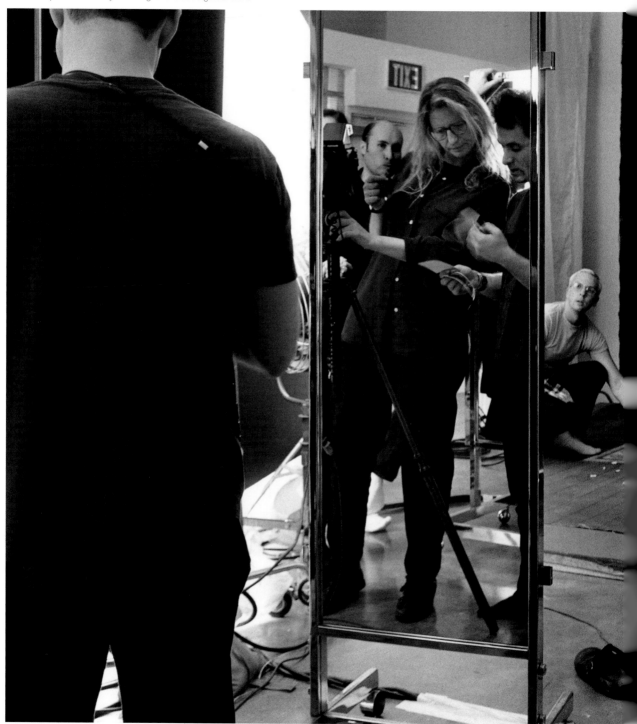

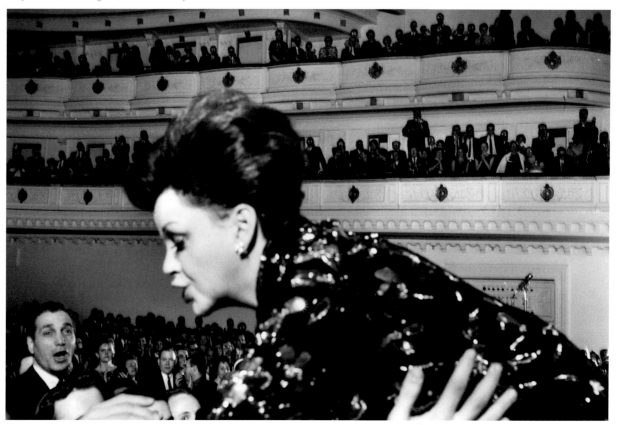

Henri Cartier-Bresson's senior−citizen bus pass. Paris. 1987

Cloud. Sydney, Nova Scotia. 1979

Henry Moore's *Sheep Piece*. Much Hadham, England. 1983

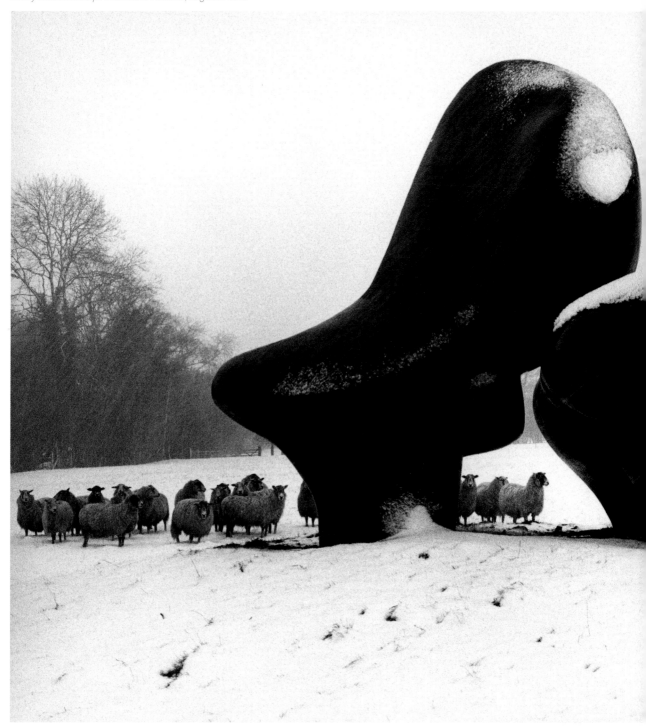

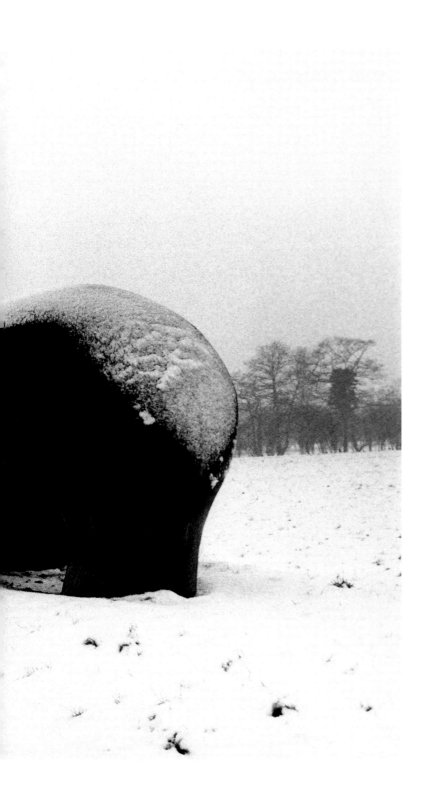

Henri Cartier-Bresson flies his kite. Provence. 1987

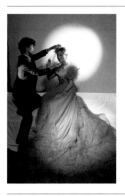

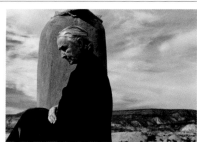

Photography was born on January 7, 1839, when François Arago told the Academy of Sciences in Paris that Louis Daguerre had fixed the fleeting image formed in a camera obscura. A year, one month and three days later, Britain's Queen Victoria was married. There's a connection: the Queen wore a white silk dress covered with lace, and her choice became a tradition. So did the bridal photograph. One hundred and fifty years later, Yao Qirong asked his wife to model the version of the Queen's gown he keeps on hand, ready for newlyweds coming to his photographic studio, 600 miles northwest of Hong Kong in the boondocks of China.

Bringing supertankers into Maine's deep-water bays to unload oil was a fresh idea in 1972. Some people were for it; some were not. A great deal was written, but it was a difficult story to photograph because nothing had happened. I took a picture of the amusement pier at Old Orchard Beach, intending to show how the hand of man had already altered the Maine coast. The tanker scheme was soon forgotten and so was what was written. Old news is an oxymoron, but old photographs can hold our attention. This fact, more than any other, I suspect, separates the ambition of photographers from the goals of the writing press. That ambition, to produce something of lasting interest, is the bedrock of this book.

Painter Georgia O'Keeffe sat on the roof of her house at Ghost Ranch. She was talking to an editor from *Life* magazine. I grew restless listening to their conversation and decided to try to take the most lopsided photograph in history. I put O'Keeffe on the left of the picture, leaving nothing but wisps of cloud and a distant hill to balance her on the right. The first frames had faults common to pictures taken during interviews. The shutter caught O'Keeffe's arms awkwardly as she gestured—or she focused on someone outside the picture. You wonder who it is. Finally, though, O'Keeffe seemed at rest, drawn into herself. Actually, her body is not relaxed. She's between query and response. She's coiled, ready to gesticulate.

Pages 14-15
Annie Leibovitz and her assistant
Robert Bean. New York City. 1991

Page 16
Ann Beattie and Lincoln Perry.
Charlottesville, Virginia. 1990

Page 17
Paddy Dunne, purveyor of coal and turf.
Dublin. 1987

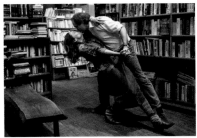

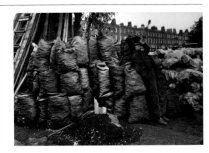

Annie Leibovitz stood on one of eight gargoyles that extend from the 61st floor of the Chrysler Building in New York City. David Parsons, a dancer, posed for her on the next gargoyle. A daredevil assistant handed Leibovitz fresh film. Watching from the safety of a terrace, I wondered if any photograph could justify the risks they were taking.

Two of my colleagues have fallen to their death while looking for the best spot from which to work: James Burke stood on a pile of loose rocks in the Himalayas, and the stones shifted suddenly. Ethan Hoffman crossed the roof of an abandoned school in New Jersey and stepped through a skylight hidden under layers of pigeon droppings.

Is taking chances important in photography? In wartime, I suppose it is, but here Leibovitz prefers a picture of Parsons she got without risk. Earlier that afternoon, downtown, the dancer scuttled across her studio floor on his knees and elbows. "He looks like he is struggling with the ground," she said.

I'm bigger than a fly. As soon as I walk through the door with a camera, I affect people's behavior. I cannot watch what they do from a spot on the wall, unnoticed. I must draw people out, often by asking what they might normally do. The answer may lead far afield. I asked writer Ann Beattie and her husband, painter Lincoln Perry. She said, "When we have nothing better, we annoy our friend Michael Williams by making out in his bookstore."

In 1976, farmers in Bowdoinham, Maine, held a competition to see whose pair of oxen could pull a sled loaded with boulders farthest in a given time. Oxen straining against their yokes were more interesting, to my eye, than wheels spinning at the county fair at Union, Maine, where they held the same contest but used tractors instead.

Eleven years later in Ireland, it was my luck that Paddy Dunne, purveyor of coal and turf, had not gone modern and bought a forklift truck. The bend to his spine, as he reached for a bag of peat, reminded me of a man who delivered ice to my grandmother's house in the 1940s. He'd curve his body back in a similar pose to pull a block of ice from his truck. Today the refrigerator has replaced the iceman as completely as the tractor has replaced the ox. It's rare to see the singular skills of physical labor.

Pages 18-19
Trainers greet jockeys after a race.
Curragh racetrack. Dublin. 1987

Page 20
Brassaï. Paris. 1981

Page 21
Georgia O'Keeffe with favorite stone.
Abiquiu, New Mexico. 1966

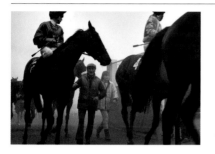

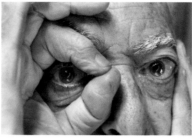

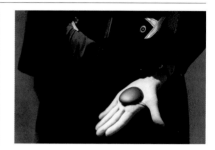

There's such a thing as baggage creep. If I carried five pounds of camera equipment on my shoulder in the 1950s, the weight by 1987 was nearer thirty. I much prefer to work alone, but walking around Dublin for a week looking for pictures, I hired a boy to carry some of the gear. When we took a train to Curragh racetrack, on the outskirts of town, he went off to look for a dining car and breakfast. While he was gone, the train halted in the middle of a field. There was no station, no platform and no announcement. A passenger, who was getting off, told me it was the stop for the track. A path led past trees to a grandstand that was barely visible in the morning fog. My assistant, who was nowhere in sight, carried a tripod that was essential for a picture I planned to take. As the train started to move, he leapt from its far end to join me. By then, anxiety had focused my mind. I won't mention brand names, but I'd already decided what 10 pounds of gear I'd never carry in the future.

The photographer Brassaï stood in the doorway to his studio. I moved a camera close to his face. My fingers were around the barrel as I focused the lens. Brassaï's fingers came up to his eye to mimic mine. *Snap!* I wasn't sure I'd caught his gesture. I asked him to repeat it. He did, except now he was pleasing me, not teasing me. Different muscles were in play, and the gesture looked posed. No matter; the first frame turned out fine. He asked permission to send a copy to people asking for his portrait.

The stone Georgia O'Keeffe liked best in her rock collection (she told me when I asked) was one photographer Eliot Porter had found on a rafting trip they'd taken together. With a grin, she said she'd stolen it from him. Years later Porter would tell writer Terry Tempest Williams that he and his wife had invited O'Keeffe to Thanksgiving dinner after they returned from the trip. The stone was in the living room, and while the Porters were in the kitchen preparing food, it disappeared. O'Keeffe said nothing. Porter said nothing. "The next time I saw my black smooth stone," Porter told Williams, "it was in the palm of O'Keeffe's hand in a photograph in *Life* magazine taken by John Loengard."

Page 22
Bill Cosby. Beverly Hills. 1969

Page 23
Negative of Bill Cosby. New York City. 1994

Pages 24-25
Supper intermission at the opera
Glyndebourne, England. 1968

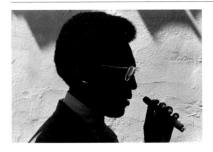

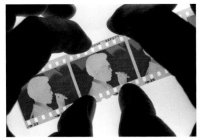

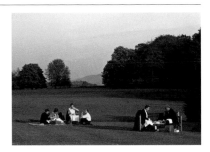

Etienne de Silhouette, Louis XV's finance minister, tried to reduce spending by nobles at the French court, and as a result, his name was attached to the inexpensive version of many items. For example, a profile cut from black paper was less expensive than a miniature oil painting. *Le portrait à la silhouette* became popular at the French court at around the time of the American Revolution.

Two centuries later I underexposed the comedian Bill Cosby's profile as he stood beside his whitewashed garage. His metal-framed eyeglasses reflect the bright surroundings and are not in silhouette. That's the picture's secret, if photographs have secrets.

The original of most photographs taken in the 19th and 20th centuries is a negative. The negative was in the subject's presence when the picture was taken. It was almost certainly handled by the photographer. But except for ones made on paper before glass plate were introduced in 1851, there is no market for them. Collectors are not interested. Most museums won't accept them. Nevertheless, as photographer Bob Adelman observed, "When a photographer loses a good print, he's annoyed for a while. When he loses a good negative, he's upset forever."

In 1992, if the curator of the Paul Strand Archive took a print from the bank vault where it was kept, he insured it for $125,000. If he brought out the negative from which Strand had made the print, he insured it for its market value too—$125. Intrigued by this discrepancy, I began to photograph the negatives of famous pictures, each held in the hand of a person who kept it safe. Everyone was pleased to have their negative get some attention, except one widow who thought what I proposed was odd. She said no. When I photographed my own fingers and my own negative, I didn't.

During supper intermission at the Glyndebourne Opera, members of the audience often picnic on the lawn. I was pleased I'd made so horizontal a composition work, but it's the juxtaposition of evening dress with the rustic setting that's important. It's reality, not composition, that is startling. But what reality? The sky is not blue. The grass is not green. Nothing moves. And yet, the photograph is an accurate record of the scene. That's an accurate inaccuracy—a paradox—and a bit of a mystery.

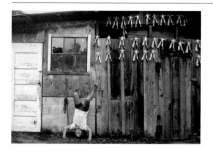

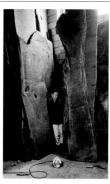

The Waipio Valley, on the island of Hawaii, is full of nature that is a green mess. At least it was to me that morning. I was thirsting for a sign of human order. I pressed my guide to tell me what he thought was unusual in the area. "The black beach?" he suggested. Yeah? Well, O.K. "The little old hotel in the valley?" Hmmm, no. "Mrs. Duldulao's taro fields?" I think he felt a bit frustrated when we came up from the valley floor for lunch. "John, there is a guy with pig jaws all over his shed. Is that the kind of thing you're looking for?" I loved it.

The man who hunted the feral pigs was not at home, but his wife said he remembered every hunt and where each jaw came from. Their son Calbert showed me he could stand on his head. Of course, the shed alone was not enough to make an interesting picture, and the pig jaws would not be interesting without the boy. But he couldn't just stand there looking at the camera. That's why I asked if he would stand on his head again. I felt like a hunter. This book is my shed.

George Nakashima made chairs, tables and cabinets from boards he bought from all over the world. Before we met, I had not known that people bid for slices of rare trees cut down anywhere in the world. Nakashima showed me pieces he stored in his warehouse. It was a time of Zen, flower power and Woodstock, and I wanted to indicate that the craft of this craftsman was not predictable. It involved both exquisite selection and the use of a buzz saw.

My 15-year-old son started to remove his shirt in a hotel room during spring vacation. That's a fact, and a photographer's job is to set such facts down with authority, from a straightforward point of view. Doing so is easy if you believe you have enough parental clout to say, "Hold it!" And, furthermore, be heard.

Page 30
Identical twins David and Peter Turnley.
Paris. 1989

Page 31
Sam Wagstaff.
New York City. 1984

Pages 32-33
Doheny & Nesbitts Pub.
Dublin. 1987

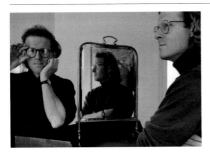

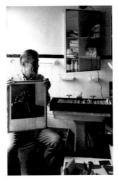

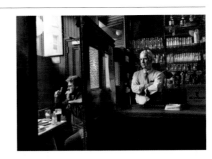

I want to show things as they are, not as they are expected to be. Still, I hope my photographs induce feelings quite different from those the subject might itself evoke. I hunt beauty and mystery in situations and do my best to catch them unaware.

Sam Wagstaff, a former curator at the Detroit Institute of Arts, started buying photographs for himself in 1973, when their value was only beginning to be apparent to the art world. In 1984 he sold his collection to the Getty Museum in Los Angeles for big bucks and was preparing to ship it off to California. The bathroom where he kept his files had the ad hoc air of photography before it hit prime time. It was also a dead ringer for one where my father showed me how to develop film.

Writer David Hanly described the sound a keg of beer makes hitting the pavement as it's delivered to his favorite pub in Dublin. I liked the image he drew in the mind's eye, but I didn't know how to photograph a thud—or a bounce, for that matter. A thudding, bouncing barrel becomes motionless and silent in a still picture. Arriving at the pub, I found Hanly sitting by the window, chatting with a friend. As I waited for them to finish, the owner sidled down the bar, and two pictures came together. On the left, the friend gestured as he talked. On the right, Tom Nesbitt stood behind the bar, lost in thought.

Sound and silence.

Pages 34-35
James Van Der Zee photographs Eubie Blake.
New York City. 1981

Page 36
Carl Mydans.
Larchmont, New York. 1985

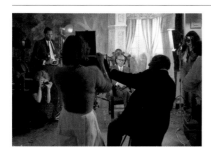

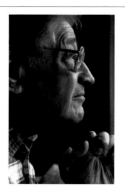

Fifty years ago, any small news event in New York might attract 20 or more still photographers. Everyone jockeyed for the best position, and the only rule was that you should not block another photographer's shot. If you did, you might find the sharp corner of a Speed Graphic camera in your ear. There was no time for explanations.

In 1981, I was midway through a story on photographers born in the 19th century. Action and variety are difficult to find in a story that is essentially a series of portraits. When James Van Der Zee, 95, was scheduled to photograph 98-year-old composer Eubie Blake at a gallery on Madison Avenue, I jumped at the chance to be there.

Photographers buzzed around the two men as they chatted during the preliminary social hour. A photographer might take pictures on the left—*click-click-click*—then run over to the right—*click-click-click*—then around behind—*click-click-click*—and then over to the left again. They were taking pictures by the pound. Nothing was happening.

I looked around. I borrowed a ladder to see how things appeared from the ceiling. In the end I figured I could straddle an old chest with my tripod and, squeezing behind it, have a view of Van Der Zee silhouetted against Blake and the background. I included part of the chorus of photographers.

I waited for Van Der Zee to start. As he did, a photographer, noticing my different position, came over and stood in front of me. I grabbed her by the shoulder, gesturing and grunting to show how wide my field of view was. (Luckily, I wasn't using a Speed Graphic.) Van Der Zee made his exposure in a way I'd never seen. There was no shutter. He just took off his lens cap and put it back on in silence as we all went *click-click-click.*

Carl Mydans photographed the Russo-Finnish War in 1939. Then he and his wife Shelley (a *Life* correspondent) covered the Sino-Japanese War in 1941 and were captured by the Japanese in the Philippines shortly after the attack on Pearl Harbor. They were released in a 1943 prisoner exchange. Mydans went on to cover the rest of World War II in Italy and France and in the Philippines again. He also photographed the war in Korea in 1950. He told me, "Sometimes you got up in the morning and you felt that no matter what you did, you couldn't get hurt. And sometimes you got up in the morning and you felt that whatever you did, you would get hurt."

"Did that stop you?" I asked.

"No," he replied. "It just made me all the more scared."

Page 37
Jacques-Henri Lartigue at
40 Rue Cortambert. Paris. 1981

Pages 38-39
Jacques-Henri Lartigue at home.
Paris. 1981

Page 40
City Lights bookstore.
North Beach, San Francisco. 1990

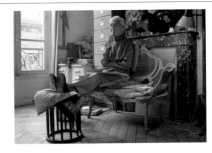

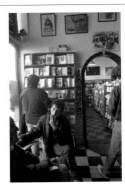

In 1905 Jacques-Henri Lartigue, age 11, took a picture of his cousin Bichonnade leaping off his parents' terrace in Paris. Seventy-six years later I asked him to return to the spot. The current owner greeted him as a national treasure, and Lartigue began to toss a pair of inner tubes into the air for fun. Amid the tossing, there was one exposure where his expression is right, the tubes are right and the arm is right, but I have cut off his foot. Often if something is imperfect in a photograph, I think it makes the picture seem more real. Photographs that are too smooth and perfect seem less than honest. On the other hand, sometimes an imperfection is just annoying. I'm tempted to cheat and ask a retoucher to put the foot back in. Of course, then I'd probably think the photograph was too slick, too smooth, too perfect. Perhaps the ancient Greeks had a word for this kind of agony.

A student asked me after a lecture in Dar es Salaam, Tanzania, "Why so many pictures of old people?" I have been looking for a good answer ever since and may have it here: When he was six, someone photographed Jacques-Henri Lartigue carrying a camera under his arm. He's remembered now for the pictures he took with it then. No one paid them much attention until he was 65 years old. I met him 22 years after that. Which is to say: Lartigue looked cute when he was six. Who doesn't? But at 87, he looked beautiful.

I phoned poet Lawrence Ferlinghetti from New York. He said that he had been photographed too often and did not wish to be again. He also said, "Take any pictures you want in the bookstore." When I arrived, I asked the cashier to call her boss in his office to see if he had changed his mind. He hadn't. Then, not five minutes later, there he was, chatting with an Italian poet right in the room where I was taking pictures. Understand, if someone's on the lam and does not want to be photographed, that's O.K. (it's happened). But I felt Ferlinghetti was courting publicity while wearily refusing it. The other thing about him that I might have noticed—well, that's his nose—I left in the corner of the picture.

Page 41
Richard Avedon at his studio.
New York City. 1994

Page 42
Café Vesuvio.
North Beach, San Francisco. 1990

Page 43
Zephyr and Jill Gill.
New York City. 1982

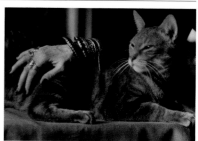

I like to use the peculiarity of the moment to make a photograph, the way an oyster takes in a grain of sand and makes a pearl.
As when fashion photographer Richard Avedon sat down in front of a demi-doppelgänger from his exhibition titled *In the American West.*

What's hidden seems mysterious, but what's hidden by wicker seems sinister.

We accept our hands for what they are. We don't diet in order to wear smaller rings, or ask surgeons to give our thumbs a less ethnic shape. Many of us ask fortune tellers to read the future in the folds of our palms. Hands are telling. A close friend asked to have her portrait taken, then said, "Why not do Zephyr too?" She plunked the cat down on a table, her hand there to soothe it. It was the best portrait I took that day.

Page 44
Pryor International Doll Library.
Greenwich, Connecticut. 1972

Page 45
The vestry at Maynooth College.
Maynooth, Ireland. 1991

Pages 46-47
Martha Reeves of Martha Reeves and the
Vandellas. New York City. 1965

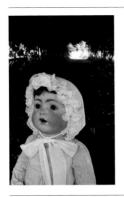

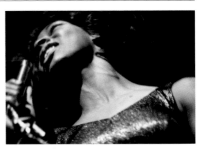

Life magazine asked a half dozen photographers to take pictures of dolls for a Christmas issue. Bill Brandt's doll was sitting in a London parlor looking startled. Elliott Erwitt's Raggedy Ann and Andy were at a table, staring at miniature Anns and Andys on their plates. Hiro chopped off strands of his own hair to give his doll a distraught look. Mystery. Mystery. Mystery. Me too. I put a larger-than-life doll in the dark tunnel of an arbor.

At Maynooth College, where Catholic priests are trained, an elderly monsignor burst into the vestry and told me to stop taking pictures. He bellowed that I must be in cahoots with the school's administration to cover up a proper scandal. It seems new rules allowed seminarians to wear civilian clothes, not clerical collar and robe, to class. He wanted me to photograph a lecture hall filled with priests-to-be in blue jeans. He was certain the picture would shock the Irish public. Possibly he was right, but my goal was different. I was avoiding mufti. I wanted to show the sort of alumni his students would become.

A problem for photographers to solve in the 1960s was how to keep microphones out of the faces of rock-'n'-roll performers.

Pages 48-49
Louis Armstrong and trombonist Tyree Glenn.
Atlantic City. 1965

Page 50
James Rosenquist.
New York City. 1987

Page 51
Marilyn Monroe.
New York City. 1957

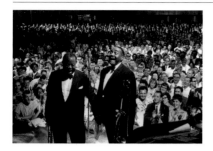

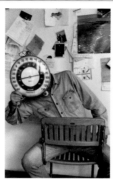

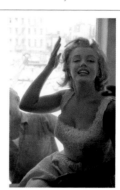

Louis Armstrong said his willingness to stand up and talk to the crowd distinguished him from other good trumpet players in bands of the 1920s. His rapport with an audience was remarkable, but showing his performance and the audience's reaction in a single photograph was difficult. He faced one way; they faced the other. At the ballroom on the Steel Pier in Atlantic City, the crowd stood shoulder to shoulder, closer to the performers, and closer to one another, than most concert halls would allow. I sat onstage next to the drummer. When Armstrong sang *Hello, Dolly!* he spiraled about, and the embrace of his listeners was clear as could be.

When James Rosenquist asked for a thermometer that was hanging on his fire escape, I didn't say, "Put that thing down. I'm taking your portrait!" Why stop a prominent American painter from cutting up? Reportorially, that would make no sense at all.

Marilyn Monroe was asked to take part in the cornerstone-laying ceremony for a new Time & Life Building in New York City. Her presence guaranteed newspaper coverage, but as a young journalist, I believed the *Life* picture editor had responded to corporate pressure— "Are you sending a photographer?"— by sending the most expendable photographer around. Or so I thought. I filed the pictures away as a record of a publicity stunt. My son noticed a sheet of contact prints 30 years later. "That's Marilyn? That's good," he said.

Charles has good taste, and his comment made me look again. Of course, at high noon on Sixth Avenue, Venus herself might seem ordinary, so being next to a screen goddess had not been a big deal. But at one point, a construction worker peeked in behind Monroe, then ducked away. He turned an artificial 'event' into a real one. Pictures of the incident appeared in the *Daily News* and the *Journal-American*, but this one was only noticed, three decades later, by Charles. Its presence here demonstrates the luck a moment needs to be included in the history of our time.

Page 52
Ronald Reagan.
Fresno, California. 1966

Page 53
Herblock.
Washington D.C. 1990

Page 54
Jennifer Loengard.
New York City. 1978

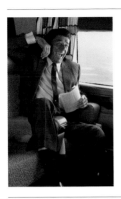

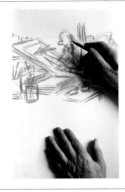

Ronald Reagan seemed sure to win the Republican nomination for Governor of California. A sports car I'd rented drew a better crowd than his opponent did at a rally on a beach near Los Angeles. And yet the movie star seemed uptight in front of the still camera— until the morning, a few days before the primary, when he started to barnstorm the state by air. Waiting for a committee to arrive to greet him on the tarmac at Fresno, Reagan swapped jokes with his staff in the rear of the plane. When he guffawed in my presence, I thought his glee reflected his confidence in victory. That was then. Now it seems more likely it reflected the fact the aircraft was on the ground. No one on board mentioned a fear of flying, but a decade after Reagan left the presidency, his authorized biography described his state of mind that morning: "Only sheer will would have made him conquer his 30-year fear of airplanes, and consent to a series of stop-go flights in a battered white DC-3."

At home, Herbert Lawrence Block drew a self-portrait for me. Then he left for the Washington *Post*, to show reporters sketches for the next morning's editorial-page cartoon. He wanted their comment and advice. "Sure, tag along," said the *Post's* publicity woman. "But we can't let you take pictures in the newsroom. It disturbs the reporters." Imagine the Herblock cartoon! She's standing athwart the entrance to the *Post*, under a banner that reads, "It bothers the press to let the press work here."

Studio photographers can sit in a room and wait for a subject to walk through the door. Journalists can't. Still, it happens. In the master bedroom, my wife Eleanor helped our daughter Jennifer get ready for her Valentine's Day piano recital.

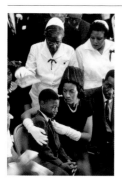

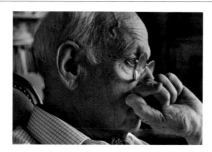

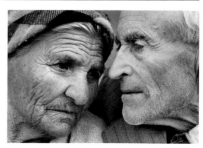

Medgar Evers, a 37-year-old N.A.A.C.P. field secretary in Mississippi, had been ambushed—shot dead in his driveway. At the funeral, Myrlie Evers, his widow, comforted their son Darryl Kenyatta. Taking pictures of mourners may not be the tactful thing to do at a funeral, but their tender image appeared on the cover of *Life* magazine within the week. I took pride in that.

No photographer has had a more powerful effect on other photographers than Henri Cartier-Bresson, but— thank you—he truly hated to have his picture taken. "I must stay anonymous. I am a street photographer." That was the stand he took for more than 40 years, but in celebration of an exhibit at New York's Museum of Modern Art, he relented—a bit. He agreed to be the subject of a picture story. When I first pointed a camera in his direction, though, I felt as if I were the clumsiest dentist in the world and my patient knew it. He cringed. He reached for his camera and started taking pictures of me. *"Click! Click! Ah–zeep! Ah–zeep!"* (The camera I was using wound film with a motor.) We sounded like two insects getting interested in each other. He thought this amusing and giggled. I moved close to his face. He looked reflective for a moment. "Oh, how I hate to be photographed!" he said.

The oldest people in Italy were said to live in Campodimele, a hill town south of Rome. I expected to find Methuselah, but words lie. The average age of Campodimelians is the highest in Italy, that's true. But no one remaining in the village is exceptionally old. Young people leave because there's no work there. However, the vice of journalism is superlatives. I asked to meet the oldest couple in town.

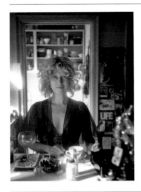

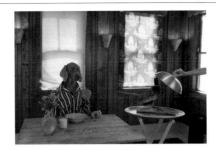

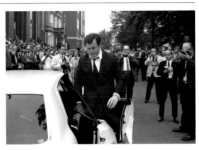

My cousin Martha took her lifelong friend Elizabeth to a new hairdresser, and I took this picture for the record, mentioning Medusa as I did. Wash my mouth out with soap! That killed it. She never went back.

Journalists change subjects all the time, so taking pictures of the same dogs over and over is not something I'm ever likely to do. William Wegman does that and does it splendidly. He started in the 1970s, and 20 years later was still going strong when I photographed a session at his house in Maine. This is his setup, not mine—but that almost goes without saying. Every photograph copies someone else's labor. When I photograph a sunset, no one thinks I get credit for setting the sun.

Edward Kennedy, 37-year-old Senator from Massachusetts, was heir apparent to the presidency. I photographed him throughout May and June in 1969. The pictures were about to go to press on July 19 when Kennedy drove his car off the bridge between Chappaquiddick and Martha's Vineyard islands. Mary Jo Kopechne, in the back seat, drowned. The Senator waited eight hours to report the accident to the police, then went into seclusion. Everyone had questions. Kennedy would not appear in public until Kopechne's funeral in Pennsylvania, three days later. The occasion was different from earlier public events I'd attended with Senator Kennedy. It was big news. There was competition. We all tried to guess the best place to be standing when he arrived. My guess? Kennedy's press secretary told me the Senator would ride beside the driver in the car, as usual. I chose to be on Kennedy's side as he arrived at the church. Despite his neck brace, he leapt from the car and quickly turned to help his wife and others exit from the back. The moment was a taut footnote to the political history of the United States.

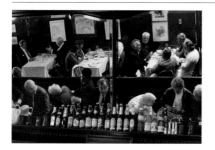

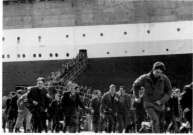

When the Queen of England toured Ethiopia in 1965, her courtiers asked the press not to take pictures while she ate at the banquet Emperor Haile Selassie gave in her honor. They feared the royal face might look bizarre if caught chewing. In San Francisco the same courtesy seemed due hoi polloi. The people had pushed back from the luncheon table or were waiting at the bar for a second seating. The moment was safe enough for Elizabeth II, if a bit untidy.

Workers building the ocean liner *Queen Elizabeth II* disembarked in a controlled and stately way. They started to line up at the gangplanks a quarter of an hour before the whistle blew for quitting time. Then foremen led them sedately down to the dock, the regulation being, I suppose, "Don't rock the boat." When they hit land, their pace changed.

With more than 40 years' experience taking pictures, I knew exactly what I wanted when Civil War historian Shelby Foote sat down.

"Do you want the dog in the picture?" he asked.

"No," I said. "And please don't look at the camera."

Page 68
Swan.
Stratford-upon-Avon, England. 1968

Page 69
Charles Loengard in barn.
Woolwich, Maine. 1967

Page 70
1850 Shaker building.
Sabbathday Lake, Maine. 1966

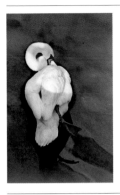

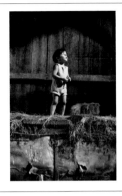

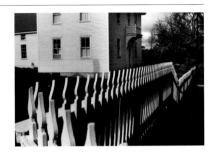

Even when they stand on one leg in shallow water and preen themselves, it is almost impossible to go wrong photographing swans. This photograph records one swan's sinuous shape. I have done no more than isolate it, which is the most important control a photographer has.

My son Charles watched swallows fly above his head in the barn, but the truth is, I have photographed no other three-year-old boy as he explores his world, so I don't know if loving Charles made this a better photograph.

Thomas Merton, a Trappist monk, wrote, "The peculiar grace of a Shaker chair is due to the fact that it was made by someone capable of believing an angel might come and sit on it." That's all very well, and I was on my best behavior the first day I visited the Shaker community at Sabbathday Lake, Maine. I was polite, sympathetic and curious. But after lunch I went out looking for action. Sunlight on the picket fence across the street was as real as a fistfight.

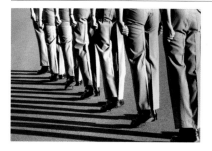

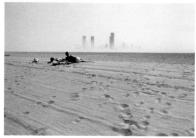

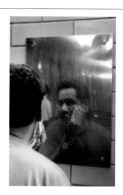

I discovered photography 107 years after Louis Daguerre, on a Sunday afternoon when my father said he planned to buy a new camera now that World War II was over. The idea that the thing he mentioned could "take pictures" made me leap up and rush to the drugstore on the corner to buy film for the box camera that was at home. "What size?" the druggist asked. "Size?" I said. Who said photography was easy?

Sometime in the 1960s an astronaut snapped the earth from space and made the ultimate photographic first. The first picture of the Second Coming will be thrilling, but aside from that, there are few virgin sights left for the camera. I'm glad I found my little crumb. I like to think this is the first photograph of a *right face* ever made.

I did not plan it. At Duntroon, Australia's military academy, cadets drilled with more snap than I and my fellow draftees ever displayed at Fort Bragg, North Carolina. Wanting to get at the heart of their precision, I pulled out a small telephoto lens and, from a comfortable distance, isolated their feet—thankful that I was no longer a soldier myself.

At President John F. Kennedy's funeral (a sunny day), photographers were lined up in the White House driveway, passing the word back and forth that it was "5.6." ("Yeah, it's 5.6—Charlie, it's 5.6.") My God, the exposure with the film they were using was f/5.6 every sunny day of their lives.

The point is that there are only about a dozen different exposures you can use in photography. It doesn't take a genius to figure out which one of 12 possibilities is right—especially on a sunny day. Sunshine is so constant around the earth that film is sold according to its proper exposure in sunlight. A 400-speed film needs 1/400th of a second in the sun with the lens set at f/16. A 200-speed film needs 1/200th of a second. It is the same wherever the sun shines, even on the moon.

A law required Long Beach, California, to spend a percentage of its oil revenue to beautify itself. So it camouflaged offshore oil derricks to look like apartment towers. I tried photographing the towers directly, but the photographs only proved they existed. It seemed they needed to be the focus of a picture, not its subject. I came down from Los Angeles, again, early one Sunday morning. Two men and the footprints of Saturday's visitors provided a tapestry into which to weave the towers. Beyond that, it was 1/400th at f/16, just like the film box said.

Wilbert Rideau took three bank employees hostage during a robbery in 1961. He stabbed a woman cashier to death, shot another, who lived, and wounded the bank's manager, who ran for his life. Rideau was convicted of murder and sentenced to death. In 1972, while he continued to appeal his conviction, the Supreme Court canceled all existing death sentences. I met Rideau 20 years after that. By then he had become editor of the inmate newspaper, *The Angolite* and turned it into an award-winning publication.

Rideau informed me while he shaved, "The mirror lets me see who's coming at me from behind." Earlier, he'd refused to turn his back to a column of prisoners carrying hoes as they returned from the prison farm. The marchers were some distance off and under guard. His anxiety was not paranoid. It was shared. A warden described the extra scrutiny given prisoners assigned to Rideau's barracks. "We don't want anyone who wants to be famous and shivs him," he told *Newsweek* magazine.

Rideau's fourth trial for the murder ended with a verdict of manslaughter in 2005. The 62-year-old prisoner was immediately free, having served 44 years already for that crime. The *Times-Picayune* newspaper reported that his lawyers urged him to leave town as quickly as possible, just in case anyone wanted to stir up trouble.

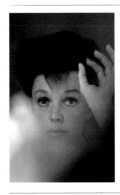

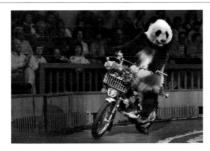

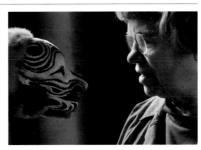

When actress Marilyn Monroe died, there was gossip about other stars who were flirting with barbiturates. *Life* magazine asked me to photograph singer Judy Garland—just in case. I don't remember what pretext was used, but there she was in her dressing room in Las Vegas. The rumors seemed flimsy and the whole thing shabby. I had photographed her two years before and liked her very much. I hoped my pictures would not be published.

They weren't. Garland did die from barbiturates, but not so soon as *Life* had feared. Six years later in London, a coroner ruled her death was a mistake, "an incautious self-overdosage."

She was 47.

"A giant panda practices for the Tour de France," was all *Travel & Leisure* magazine told its readers about this bear riding a motorbike at the Acrobatic Theater of Shanghai. That was probably enough. Of course, if you could read the panda's mind, there'd be a lot more to say.

I asked anthropologist Margaret Mead to move closer to a colleague showing her a tribal mask at the American Museum of Natural History. Dr. Mead wondered if the object was her mirror image. I assured her this was not the case.

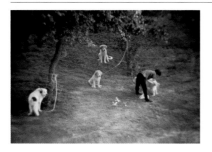

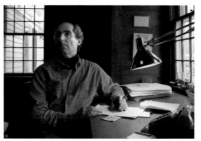

Photographs that appeared on the printed page in magazines in the 1950s convinced me there was something peculiar—something odd or particular—in any situation if only I could find it.

Anyone coming to a portrait photographer's studio in the 1950s might sit beneath a skylight. The proprietor knew what the camera would show without looking through a viewfinder. He'd move about the room and chat with sitters to keep their mind off the disturbing prospect that posterity might know them only by the way they looked at that particular moment.

When I met Philip Roth in the 1990s, his umpteenth book, *Patrimony*, had just been published and he had been photographed so often that the chance one picture would describe him to posterity seemed slim. I asked him to sit at his desk and write. He did, facing the window and looking self-conscious, as one might expect. I started to take pictures and told him he looked splendid. I hoped something might happen. A writer with me asked a question. Roth snapped about, instantly oblivious to the camera. He had the look of a querulous pheasant, just flushed and ready for flight.

"I am among the least automotive of men," novelist John Updike wrote when describing vehicles he had owned since college. A magazine wanted me to illustrate the piece. Its art director asked, "You'd have no trouble showing him with some bit of a car, would you, mate?" I didn't.

Page 83
Sebastião Salgado and his 1991 negative
of oil field fires in Kuwait. Paris. 1993

Pages 84-85
John Byrna, groundskeeper,
St Martin's Green. Dublin. 1987

Page 86
Hurricane-destroyed statue of
Pierre le Moyne. Near Biloxi, Mississippi. 1970

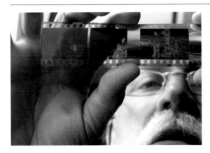

Sebastião Salgado photographed workmen replacing a war-damaged wellhead in Kuwait's Greater Burhan oil fields. The Brazilian economist-turned-photographer said, "The working class is disappearing forever. I want to pay homage to them."

The finest photographs are simply records of fact that provide such an unexpected sense of order, they take your breath away.

If I had a photographic creed, it would be to try to evoke feeling from objects that are not evocative, to find movement in situations that are still, and to capture beauty in subjects that have none.

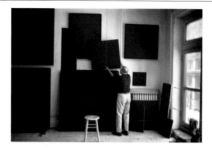

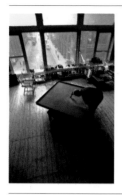

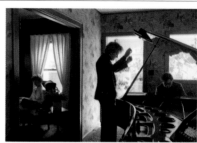

A month after my photographs of Ad Reinhardt were published in 1967, we ran into each other in a line to buy tickets at a movie theater opposite Bloomingdale's department store. "My doctor did not like all those pictures of me bending over," the 54-year-old painter said. He seemed cheery and robust, so I didn't ask him to explain. I wish I had. Six months later, he was dead.

What Ad Reinhardt did was quite wonderful. The subtly different, near black geometric shapes in his paintings came back from a show in Los Angeles scuffed. So he just repainted them and hung them up to dry.

Emanuel Ax plays a piano very loudly. The wife of Michael Palmer, conductor of the Wichita Symphony, might not sit so close to her husband and the pianist while they rehearsed unless a photographer had said there was nothing of interest on the left side of the room, would she?

Page 92
Irasburg, Vermont. 1969

Page 93
Andrea Marcovicci.
New York City. 1987

Page 94
The Reverend Jesse Jackson.
Chicago. 1968

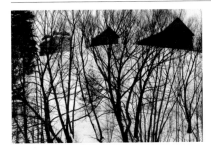

An editor who had retired to New England wrote an article about the problems an African-American family faced in a small Vermont town. I wanted to make the setting of the story vivid, but the family had moved away. There was little that was pertinent left to photograph. I brought along a snapshot of the family, blown up to poster size, thinking to use it somehow to illustrate their absence. But as I drove along a back road, their house and shed and barn loomed up along a ridge. An intricate tracery of barren trees screened the buildings from the road and entangled the family's former home more symbolically in fact than anything I might have invented.

Cabaret singer Andrea Marcovicci was simply wrong. "I'm too exotic to be beautiful," she said.

The 27-year-old Baptist preacher Jesse Jackson had been with Martin Luther King when Dr. King was assassinated six months earlier. I arrived at Jackson's home at the time he set and then waited an hour until he loftily announced that he was ready for the camera. Well, O.K. No one is obliged to be photographed, but I was annoyed. Of course, there's nothing a photographer can do. Someone photogenic will look good no matter what you think, but that's small potatoes. If the camera has a shortcoming, it is that someone wonderful may not be photogenic.

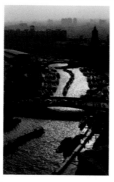

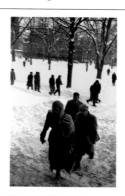

Natural light is the photographic term used to describe light not introduced to the scene by the photographer. Seven pictures in this book use artificial light—the term for illumination the photographer brings with him. Here it was the headlights of my car.

Historian Dorothy Borg, my aunt, worked in Shanghai for a short time after World War II. Before I went there for the first time in 1987, I asked her to describe what the city had been like. "We lived in a tall building called Broadway Mansions," she said. "Terrible, terrible crowds, terrible poverty, terrible misery, terrible traffic. The Japanese had carted off everything they could when they left, including plumbing and radiators." She went on to describe the moaning sound of a mob passing the hotel and crossing over Suzhou Creek on its way to witness executions shortly before the Communists took over. "I'm not much help," she added. That was not true. She'd given me a point of view. When I got to the roof of her building, I felt as if I were returning to a place I'd never been.

Harvard and Radcliffe colleges began joint classes during World War II, and 10 years later Harvard claimed it was coeducational in everything but name. Nevertheless just one of 21 figures hurrying to class in Harvard Yard is clearly female. It's likely that members of the more organized and purposeful sex were already where they were going.

194

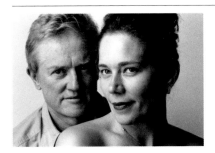

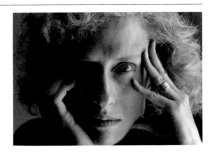

The reason I like being a still photographer is that I do it all myself. Architects need patrons, and composers need orchestras. Actors, singers and musicians require audiences, and a writer may be rewritten by editors. But there is not much anyone can do to improve a photograph when it leaves my hands. Photographers are a bit like sculptors, in this way. What's carved from stone is expected to be permanent. This photograph was taken to announce my daughter's engagement.

Only one wall of Gore Vidal's hotel room was free enough of bric-a-brac to use as a background. When he was seated, though, the light came from behind his left ear and was harsh. I explained this and asked if he would turn around to face the window. He said no. He said his left profile was so much better than his right, he would not turn.

I moved in. The shadowed side of his face became central to the picture, but Vidal's attitude had so discombobulated me I forgot to mention that I had photographed him before, in 1960, when he ran unsuccessfully for Congress. He had been slender then. (I guess I had been too.) Up close now, the author of *Myra Breckinridge* looked a bit like the aging Henry James, albeit more sensuous. Any writer might like to be compared to James, I suppose, but not visually. So I did not tell him that either.

I was just back from China, where I thought I'd taken some nifty pictures. It turned out I hadn't. I'd argued with officials to get permission to photograph what interested me. When developed the pictures turned out to be insipid, hardly worth printing. So I was not especially confident a few days later flying to Chicago to photograph a mystery writer for the *Sunday Times* of London. A sleepy man answered the door. Remains of Saturday night's dinner party were evident. Neither he nor Sarah Paretsky, when she came down, seemed thrilled to see a photographer who'd arrived on time. However, after waiting a few minutes while things were tidied up, I spent a day where every picture turned out better than it deserved to be. Something that might have looked flat-footed had style. Something that might have looked contrived seemed fanciful. It started with a close-up in her writing room that might have looked static. It wasn't. It had energy. *Whah-hoo!*

Page 101
Louis Armstrong applies balm to his lip.
Las Vegas. 1965

Page 102
Blood-circulation exercise.
Shanghai. 1987

Page 103
Mariah Carey.
New York City. 1990

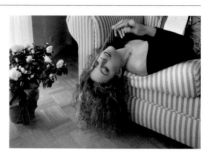

An editor who knew Louis Armstrong well suggested I show the trumpet player treating his lip after a performance. I wasn't particularly interested in doing so. I thought, "Who wants to see a picture of a 65-year-old man sitting at a table rubbing balm into his lip?" And my fifth-grade music teacher had tossed me out of class for being a musical dodo, besides. Then it occurred to me that the picture might show only lips and fingers. That was peculiar. That interested me.

A journalist's job is to point out things of interest at the moment. I like the challenge of taking pictures for this reason and notice things that I might otherwise ignore.

Having a press agent in the room when taking pictures of a 21-year-old pop singer is like trying to sell jewelry with an accountant present. Caution is not what is needed. But Mariah Carey insisted. Whenever I made a suggestion, Carey would glance at her flack and the flack might shoot me down, saying "Maybe not."

The newspaper *Variety* coined the word flack in the 1930s to honor Gene Flack, an early movie publicist. *Flak* is the German acronym for *Fliegerabwehrkanonen*, which means antiaircraft guns. Allied pilots adopted it in World War II.

A phone call from Carey's girlfriend interrupted the photo session. The singer turned topsy-turvy in her chair to talk. When she finished, I said, "Please stay that way." There was no flak from her flack.

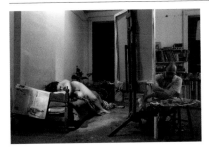

Philip Pearlstein paints in color, so why photograph him in black and white? Well, what would color add? It would show the color of the walls. The colors of the paint splattered on the floor. The color of his shirt. The color of her hair. That additional information would make it harder to notice that his arms mimic her legs and that this photograph is about the relationship of things: a painter to his model, a model to a room, a painter to his work.

Luke Pontifell, a sophomore at Harvard, printed 425 copies of Arthur M. Schlesinger Jr.'s 1983 essay *J.F.K Remembered* on a small hand press. During the decade after the President was assassinated, universities all across the country began to teach photography. Before that, the Harvard faculty, for example, thought photography's dependence on a subject meant it was of intellectual interest only when copying a painting, or cataloging the physiognomy of primitive tribes, or mapping the stars, or—that was about it. During the 1960s, of course, with the war in Vietnam going on, faculties were sympathetic to their students' desire to avoid the draft by staying in school. Photography is not a difficult subject. Anyone should pass. Whatever the reason, all of a sudden the Academy accepted photography. The world followed suit. Bingo! Photography was a fine art.

André Kertész left a successful career in Paris in 1936 to try his luck in the United States. He didn't have much. In 1939, World War II trapped him here. "You're looking at a dead man," he told his friend Brassaï, who visited from Paris in 1946. Indeed, Kertész's career did not take off in America until the 1960s. He never forgot the slights he suffered along the way. For instance, in 1937 the Museum of Modern Art in New York asked him to crop the pubic hair from a photograph of a nude. Forty-four years later, he was still outraged by the request. But when he offered to show me what the museum had proposed, he was presented with a dilemma. If he put his hand down accurately, the picture would not show what was cropped out. If he did not place his hand at all, I'd see only an opened book on a table. Kertész knew what to do. He left a little showing.

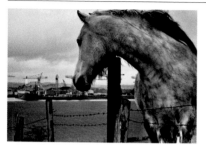

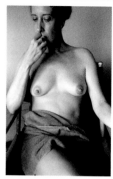

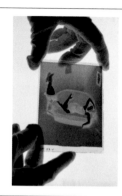

Certain photographers compose pictures like flowers—putting the interest in the center like the stamen and surrounding it with harmonious shapes, like petals. "See how pleasantly I present the subject," the picture says. Another method says, "See how everything all across the picture is related." That's the system I prefer.

At the time this picture was taken, I did not feel comfortable making a print of it in the lab where the subject was known. (I haven't had a private darkroom since 1964.) So the negative was put in an envelope and forgotten. No one cares about this now. Probably no one but me ever did.

At the age of 32, André Kertész moved to Paris from Budapest. A year later he clowned around with friends at sculptor István Beothy's studio, where dancer Magda Förstner decided to mimic the host's statuary. Kertész recorded her joke on a delicate glass plate. It is still in Paris, at the Mission du Patrimoine Photographique, where it is safe from carousing young Hungarians.

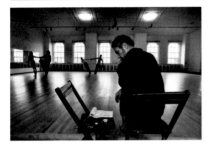

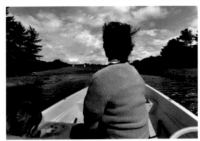

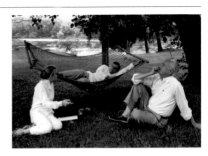

If I see a spot where interesting things are going on, I'll sit down and make myself comfortable and wait. As I get comfortable, I see more. To start, choreographer Merce Cunningham was out on the floor showing steps to his dancers, adjusting their postures and moving beside them through the dance. I'd photographed all that. Then he sat down on one of two folding chairs, and his dancers echoed the unfolded shape of the pair.

This picture of my wife and son approaching our property in Maine began a magazine story about our summer house, even though—or because—the art director thought photographing one's wife from behind was odd. Well, humph....

In China, under Chairman Mao, photographers held contests to see who could take the best photograph of a flower in a vase. (Flowers are safe subjects in dangerous times.) With an ideal image of a flower in mind, they would judge how closely each photograph resembled that ideal. Idealized photographs are found elsewhere—in advertisements, for instance—but I don't find them satisfactory. A Ming vase may be well designed and well made and beautiful for those reasons alone, but I don't think that is true of a photograph. Unless there is something a little incomplete and a little odd, it will simply look like a copy of something pretty. We won't take an interest in it.

An editor at *People* magazine brought up the painting *Déjeuner sur l'Herbe*, by Edouard Manet, before I went to photograph writer Ruth Prawer Jhabvala and filmmakers Ismail Merchant and James Ivory. It was a joke, I guess. A naked woman picnicking with two clothed men was not my subject. But at Ivory's house that Sunday (without a hint from me, and nakedness aside), the threesome dallied on the grass as if they'd just dropped from Manet's canvas.

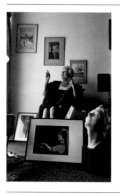

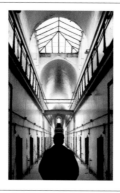

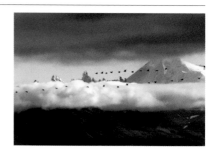

I used to think it was better not to pose a picture. I liked the idea of the eye searching for form without suggestion ("Would you sit here?") or flattery ("Lovely!").

But I noticed that if the subject was seated in a chair where the light was pleasing and the background clear, I might get a picture. And if the subject chose to sit in harsh light and the background was distracting, I might as well go home. Was it an intellectual crime, I wondered, to ask someone to move to where a picture might occur?

I also noticed that a posed picture may look candid and an unposed one may seem orchestrated. (If there were real value to not posing a subject, shouldn't a photographer bring a notary public along to authenticate the candid snaps?)

I first saw Betty Blythe in the dining room at a motion picture industry home for the aged and asked if I could photograph her. She was moving (or her apartment was being painted; I've forgotten which). Her possessions were out on the floor. I pushed a chair into the light and rearranged the pictures a bit. Then I photographed her on the fly as we talked; the picture is 50% posed and 50% candid. I think that's dandy.

There is sleight of hand in photography. With card tricks you slip something in without others seeing. In photography you make the viewer feel he's seeing everything, while at the same time you make him realize he's not. The picture seems reasonable and expectable, and then, at the last minute, you pull the rug from beneath the viewer's feet, very gently so there's a little thrill.

At Philadelphia's 150-year-old Eastern Penitentiary, the caretaker's silhouette increased the sense of depth and clarity in the picture and added scale and human interest to a straightforward record of a cell block, while the blankness of his figure withholds any accurate sense of the man's personality.

The weather in Cold Bay, Alaska, just east of the Aleutian archipelago, is cold, wet, windy and dark. People who live there say they see the sun only 30 days a year. When I arrived it was raining. I pointed in the direction of the Izembeck Wilderness Range and told everyone that if I had five minutes of sunlight, I'd have a picture. I was doing a story about government-owned land, and my audience was brass from the U.S. Fish and Wildlife Service who'd come from Washington to inspect their windswept facilities and shoot migrating geese for their freezers back home. After three days the clouds broke for a quarter of an hour. Geese flew past the Aghileen Pinnacles, approximately where I'd pointed. Standing on the shore, using a long lens, I did what needed to be done. Then I packed up and went home feeling a bit like Babe Ruth, who (it's said) pointed to the bleachers in Chicago in 1932 and hit the next pitch into them.

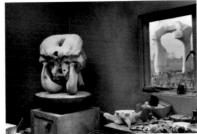

Allen Ginsberg was wreathed in tobacco smoke and drinking tea with undergraduates on the campus of the University of Kansas. I sat on the floor in front of him and played with the notion of how little of the poet's face I needed to show in order to make a portrait.

The reason sculptor Henry Moore kept an elephant skull in his studio seemed clear as day.

I often daydream of pictures before I go to take them. Although I've never found exactly what I've imagined, such dreams give me a point of view. When I spot something as interesting as what I dreamt, I start to work. As my friend photographer Gjon Mili once wrote, "A photograph is a brief collusion between foresight and chance. If I come with preconceived ideas, they do not serve as a guide, but rather are a way to precipitate an accident."

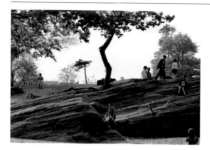

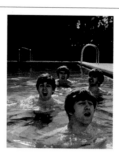

What's photographed can't be altered on reflection. Moreover, the most intriguing subjects may exist for only a moment. Anyone prone to anxiety may wonder why they got into this business. I have.

Vera Constantinova, 91, was the only member of the Russian royal family born before the revolution and alive in 1998, but the sole hint of royalty in her cottage was the look of devoted deference in the eyes of two women attending her. Princess Vera had retained her gaiety but not her passport, or even her citizenship, preferring to remain stateless until the ancien régime might be restored.

Four high school kids, the kind with fuzzy chins, arrived in Florida during a cold snap on their first trip to America. No one could find a heated pool that we could close off from the rest of the press, so we used one that was not. The kids' manager told them the cover of *Life* magazine was important and to get in the water. They did. I asked them to sing. They sang, each in his own way. They started turning blue. I said that was it. If the pool had been heated, I would have a longer story to tell.

Page 128
Maya Angelou.
Winston-Salem, North Carolina. 1992

Page 129
James Earl Carter.
Atlanta. 1994

Pages 130-131
Stephen King.
Bangor, Maine. 1989

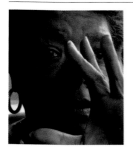

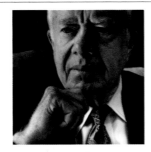

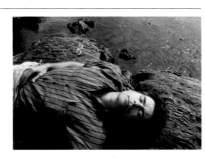

Bill Clinton had asked Maya Angelou to compose a poem for his Inauguration. She had given me her address, but it was hard to find house numbers on her street. A small mansion with tall columns looked right for a banker. A low ranch house next to it seemed right for a poet. At the last moment, I spotted a mailbox. Angelou greeted me at the door of her little Tara. With 28 days left, she said as we got started, "I'm still mulling over how to say different things, what words to use in different portions. I'm doing that this moment while you're taking pictures."

"I've been asked to make you immortal," is what I'd tell people I photographed for *People* magazine in the 1990s. Only one of them snapped back. "I thought *I'd* done that." Mostly they'd laugh. When I entered former President Jimmy Carter's office, however, it was clear that he had been immortalized too often for another photographer to make an impression with chitchat. His mind was elsewhere (in North Korea, Haiti or Plains, Georgia, for all I knew). I suggested he sit on a couch near the window where the light was best. The press secretary had told me I had half an hour, and more if needed. To everyone's surprise (well, certainly the press secretary's), after a minute or two, I said, "Thank you, sir." There was more on the President's mind than having his picture taken. I hoped it would show.

Students at photographic workshops are sometimes puzzled by what I say. Which is O.K. They can think about it. But in California, once, I told a class never to photograph anyone wearing sunglasses. They were outraged. My point was that sunglasses cover the most revealing portion of the face. Snap away at someone wearing shades, and you'll be hard pressed to get a picture as good as one that's shadeless–a person's selection in Ray-Ban isn't that interesting. Even regular glasses hide the eyes. Stephen King had a pair that was especially thick. My aim was to get the author of *The Shining* comfortable enough to take them off.

Page 132
Stefan Lorant.
Lenox, Massachusetts. 1982

Page 133
T.S. Eliot.
Cambridge, Massachusetts. 1956

Pages 134-135
Second annual Festival of Free Expression.
Paris. 1966

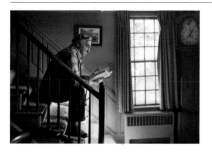

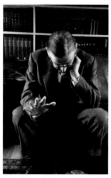

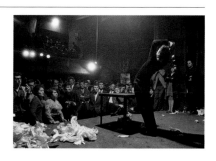

The picture was ready-made, like a ready-made suit. Editor Stefan Lorant, who started Britain's *Picture Post* magazine, was the right height and size, but the setting would have fit Franklin D. Roosevelt, or my father, had it been their home.

There is nothing very unusual about sitting on stairs, but when I suggested that he do so, I asked as if the notion were farfetched, "In your life, have you ever...?" Lorant sat. The book gave him something to do. Sunlight bounced off the rug onto his face. This is peculiar. It's also a bit peculiar to see a nearsighted man sitting on the stairs reading a book. It's a bit peculiar that the pages blur. Three little peculiarities. If the day had been cloudy, we'd have lost one of them. If we'd lost one of them, we'd have lost the picture.

T.S. Eliot delivered a lecture on poetry, and the next morning I went over to photograph him for the student newspaper. He was at a friend's house, and I was happy to pick out what was interesting in the moment—say, when Eliot tried to clarify a point he was making. The photograph appeared on the front page of the *Harvard Crimson* the next day, but as usual with a famous subject, l have no idea if he saw it or liked it.

Artist Jean-Jacques Lebel (onstage, second from the right) thought tension could alter a person's idea of self. At his *Happening*, the audience anticipated the fiddle's destruction as the performer drew it back, back, back... Then the lights went out.

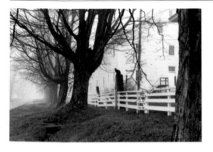

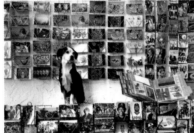

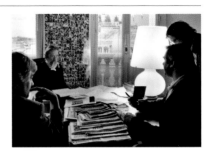

The United Society of Believers in Christ's Second Appearing was founded in upstate New York in 1776 by an immigrant Quaker from England. Its members shook and trembled with joy during meetings, and their frenzy of fits gave way to singing and dancing. Neighbors dubbed them Shaking Quakers. The name stuck, and the church thrived. By 1840, 3,500 Shakers were living in 18 communities they'd built from New England to Ohio. Other Christian sects (the Mormons, Amish and Jehovah's Witnesses, for example) continue to flourish in America. Not the Shakers. Only six individuals have joined the church in the past 50 years. One of these died, and two left. Only four Shakers are alive today.

The owner of Quantity Postcards said he kept 10,000 cards on hand. He named his dog Hobo, although hobos, even if well traveled, rarely send postcards.

Editing pictures is a serious business, and *Paris Match* magazine has a reputation for doing it well, though the solemn faces of its editors may not reflect the magazine's breezy tone. Anyway, appearance and significance often differ. One afternoon when I was 16, I took a lovely springtime picture that ran six columns wide on the front page of the local paper. People had gathered on a sunny bank of a small river to watch men in two canoes drag the quiet water for the body of an 11-year-old boy.

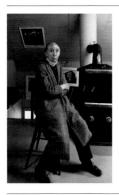

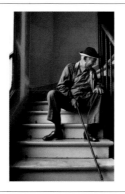

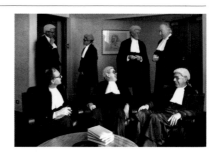

Photographer Berenice Abbott was straightforward. She did not think my story on photographers born in the 19th century was all that important. She would see me only briefly at her home north of Bangor, Maine. She had guests coming for lunch. She did not feel well.

When I arrived, we drove over to her workrooms. It was chilly, but she did not light the stove. She sat on a stool, and her posture reminded me of a portrait she'd taken of photographer Eugène Atget in 1927. He wore an overcoat too. When Atget died that year, Abbott rescued his photographs of 19th and 20th century Paris from destruction. Forty-one years later, she sold them to the Museum of Modern Art in New York for a sum that, she now sniffed, was "too small."

Gyula Halász, painter, sculptor, journalist and photographer, moved to Paris from Brassó, Transylvania, in 1923. He made Brassaï his professional name and gained a reputation in the early 1930s by photographing Paris at night. "I photographed whatever happened to catch my attention," he said. Many things did. Pictures, books and objets d'art lined the walls of his apartment. I asked if there were some less cluttered place to work. "My studio," he said. I don't speak French. Brassaï spoke no English. Judy Fayard, *Life* magazine's European correspondent, translated for us.

Outside his apartment, we waited for the elevator. Fayard started down the stairs to see what was causing the delay. On her way, she said something in French that caught his attention. It must have been very funny. His reaction caught mine.

Members of Australia's top court sat down in their cloakroom and laughed about being photographed. They did not sober up and act like judges before filing in to hear a case about the land claims of the Aborigines. Fine with me.

Page 143
Michael and David Palmer.
Wichita, Kansas. 1978

Page 144
Jill Gill at the Felix family memorial.
Cimetière du Père-Lachaise Paris. 1991

Page 145
Cimetière du Père Lachaise.
Paris. 1991

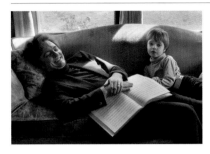

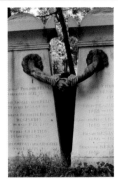

I've photographed many writers, painters, musicians and photographers. Artists make good subjects. They look as they look, not as they think other people think they should look, and they are usually friendly and sincere when someone's trying to take their picture. It may go deeper: I'm interested in what artists do, and that interest generates a point of view that probably makes me more interesting to them, so they become more interesting to the camera.
In Wichita I asked Michael Palmer, conductor of the city's symphony, to sit on a couch. His son David joined him. They chatted brightly until there was a pause in their togetherness.

New York's Museum of Modern Art in the early 1960s had a little gallery for prints and drawings next to a smaller one for photographs. I was often struck by the warm, playful mood of the pictures in the first and the earnest quality of the photographs next door. Different curators with different temperaments, perhaps, but photographers do take themselves seriously. I do. This picture would not exist except that painter Jill Gill found the Felix family's memorial handy.

Taking photographs in Paris is like using cake mix. When you add a bit of action, the view rises to the occasion.

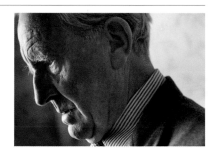

It seemed there ought to be something strange about a miniature English village in the middle of Australia, but I couldn't find it. Then I wondered if any of the cats belonging to the owner ever wandered through the town. "They might," he said. *Might* sounds like *will* to a photographer. The kitten lent scale to the scene, and the proprietor's blurred hand, leg and foot, as he leapt back from obliging me, provided a bit of action.

Photographs do not generalize. A picture of a locomotive does not explain the industrial revolution. But a part of something in a photograph can suggest the whole. The thumbnail may characterize the person.

I took J.R.R. Tolkien and his wife to lunch at the Hotel Miramar, where they stayed in Bournemouth while on vacation. A baby started to cry, and the Tolkiens said they did not think babies should be allowed in the dining room. I understood their point. I had young children at home. What surprised me was that they'd say that in front of a journalist. I don't think any writer in America would let himself seem so stuffy. Hate kids? Wow!

But Tolkien was an Oxford don, and if he weren't a bit stuffy—say about having his picture taken—it would have been taken often and I wouldn't be there to take it. All through lunch I did not let on I had not read *The Hobbit* or *The Lord of the Rings*—or, worse, that I'd tried to and did not like them. After lunch it was understood that we'd adjourn to his workroom for the photographic session and that would be it.

The room was on the top floor of the hotel, under the eaves, and contained only a card table and chair. I had not laid the groundwork for a more interesting location, and it seemed too late to start pressing such a private personage to go to his bedroom on another floor, where the light might be better and more of his personality in evidence. All I could make work in this attic was a basic headshot. But, hey! Who knows? If Hobbits mint coins, some heads might look like this.

Page 149
William Styron.
Martha's Vineyard. 1990

Page 150
Brian Lanker's portrait of
Coretta Scott King. New York City. 1988

Page 151
Beer delivery.
Ottawa, Canada. 1984

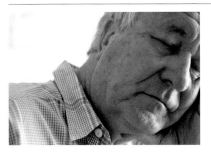

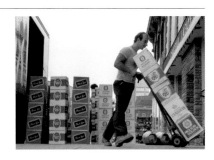

William Styron did not close his eyes intentionally. The fact is, he blinked. People often blink while being photographed, and usually such pictures are tossed away. In this case, though, the inward cast it gave to Styron's face was appropriate. The author of the novel *Sophie's Choice* had recently experienced severe melancholy, an unexpected and inexplicable loss of hope and reason. He had contemplated suicide and, for a short time, been hospitalized. When I saw him, he hoped *Darkness Visible: A Memoir of Madness*, his account of this period, might be widely read, not only as any author might, but to increase understanding of clinical depression.

Lynda Lanker stood silently, like the Statue of Liberty (if Liberty held a torch in each hand), for minutes on end while her husband Brian selected the prints for an exhibition of his portraits, "Black Women Who Changed America," that would open at the Corcoran Gallery in Washington D.C.

A television news program in Ottawa wanted to show one of the 100 photographers working on a book titled *A Day in the Life of Canada*. A camera crew followed me about until a beer delivery caught my eye. I plopped down on my belly on the pavement. Usually I don't do that. An odd perspective will often dominate a picture for no purpose. But here my chance of getting on TV seemed best if I did something out of the ordinary. The wide-angle lens I often use slides upward in its mount in order to keep vertical lines in the picture vertical; my toad's-eye view looked normal. There I was, happy as a clam, on my belly, lines straight, and on the six o'clock news.

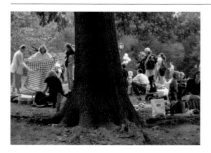

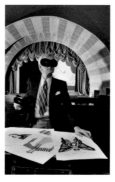

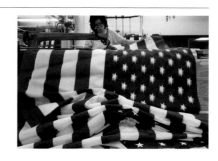

Photography was invented separately and simultaneously by two men who would never meet. Henry Fox Talbot was a gentleman scientist. Louis Daguerre painted historical dioramas. Their occupations are telling. A scientist defers to reality. A painter distills it. Photographers do both.

I rarely know my subject before taking pictures. It's like going into a shop to buy something. You don't know the salesclerks, but you all know your roles. They show you stuff. You respond. The relationship is not deep. Frank Spencer, Radio City's costume designer, showed me around his backstage workshop. He put on a mask as a joke, then started to remove it. "No, no!" I said. "I'll take it."

A presidential candidate visited the Annin & Company flag factory in New Jersey during the 1988 campaign. Reporters said that the visit was just a photo opportunity. Maybe so, but it proved a Vice President of the United States could stand in front of the American flag and get elected President. His opponent rode past cameras for a photo-op while grinning from the turret of an Army tank. He looked so out of place he remained Governor of Massachusetts.

Pages 156-157
Lady Bird Johnson.
Stonewall, Texas. 1995

Pages 158-159
TV star Roseanne poses for *Vanity Fair*.
Los Angeles. 1993

Page 160
Judy Garland at Carnegie Hall.
New York City. 1961

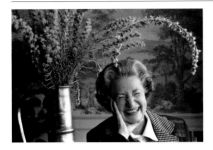

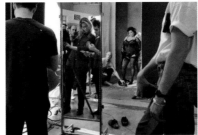

Lady Bird Johnson, widow of the 36th President of the United States, laughed at something I had said. After the picture was published, her staff bought a print for one of their number, as a retirement gift. That seemed as sincere a compliment as a photographer could get.

It is hard to show the faces of photographers at work and not get in their pictures, but on one occasion the gods took pity. *Vanity Fair* magazine wanted to include three boldface names on its cover, with a billing like **ROSANNE** PAYS HOMAGE TO COLUMBIAN PAINTER **FERNANDO BOTERO**, PHOTOGRAPHED BY **ANNIE LIEBOVITZ**. Considering the publication's ability to attract celebrities, it might have been **ZEUS** who left an unused mirror standing on the set. At any rate, with a little nudge, my subject's face— and my subject's subject's face— came together at a glance.

Maybe the fact that this is a photograph makes it easier to accept as real the expression of the man on the left and the peculiar way that singer Judy Garland bends over to receive the hands of the audience at Carnegie Hall. But this picture could just as well be a painting. Our reaction to it would not change.

The forms are interesting, not the details. His mouth. Her back and head. The flash-bright fingers at the lower right. They'd be just as exciting on a gray and black canvas 12 feet wide. What went wrong? I didn't take a good photograph, that's what. I fudged details and relied only on strong form. The camera's veracity was not needed. I'm not apologizing. I liked the rawness of the scene, and I recorded it. I like the result even if, sorry, it could be done as well by hand.

Page 161
Harvard wins!
Allston, Massachusetts. 1956

Page 162
Band leader Peter Duchin.
New York City. 1996

Page 163
Photographer Henri Cartier-Bresson's
senior-citizen bus pass. Paris. 1987

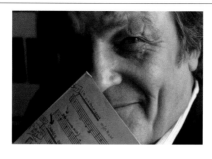

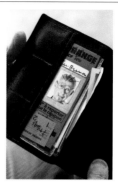

Richard G. Wharton of Harvard had sprinted from fourth place to first in the stretch to win the quarter mile in 49.2 seconds, beating three competitors by a stride. My finger on the shutter button was slow as he crossed the finish line. Pluck on Wharton's part. Luck on mine.

On rare occasion, in the 1940s, a person might go to a photographer's studio to have a portrait taken. The question when proofs came back was, Does one choose the serious picture or the smiling one? People would show the proofs around to get a variety of opinions. The consensus in my family was that smiling portraits "don't last." A photo magazine had an article on the subject in the early 1960s, and several famous photographers said the same.

So, for a long time after I became a photographer, I wouldn't take pictures when people smiled and rarely photographed someone laughing. Finally I realized this was silly, and now I don't tell jokes. I just look up from the camera and mumble, "That looks ridiculous!" And people smile.

Having talked Henri Cartier-Bresson into letting me take one picture of his face, I was eager to take another, and he was willing to show me his senior-citizen pass as we got off the bus.

In 1957, I was on a panel discussing magazine photography. Someone in the audience asked what quality was most important in a photograph. The expected answer was composition or texture or some other photographic quality much discussed at the time. I said perception. I still would.

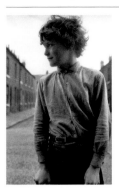

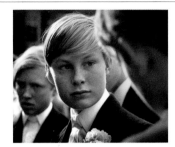

At the end of World War II, Helen Levitt began to make a documentary film in east Harlem. Private cars were scarce. Parked automobiles did not line the curb as they do today. Levitt caught life in the street without confusing bits of fender, chromium and tire in every frame. Likewise, in 1968, no cars interrupted the bleak vista behind a boy in one of the bleakest parts of England. Today I'd expect him to be familiar with washing machines, T shirts and traffic. Little wonder Walker Evans, who photographed the Great Depression, told students at Yale, "Prosperity is my aesthetic enemy."

My three children were born as I watched. I felt their personalities as clearly as if they'd just entered the room. Children's faces are important. This boy at an English boarding school was one of the few willing to face a press photographer on visitors' day. What is his occupation now? A psychiatrist? Managing director of a baby food company? Master cribbage player? I don't know, but I'm sure I'd recognize him if he came through the door.

There were only a few minutes left in the game when Harvard caught a pass on Yale's 30-yard line and scored a winning touchdown. I was on the sidelines. Shrieks of joy made me turn.

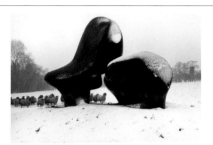

What's merely a shadow to the eye in sunlight may become a black void on film. The range of brightness a film can record is called its latitude. It hasn't changed much since photography was invented. It's as if film handles only a yard of light, while the eye holds 10.

Near Sydney, Nova Scotia, I calculated my exposure as if the bright part of the sky were the middle tone, and so cut the film's latitude in half. In 1979, Canadian law required drivers to keep their headlights on in daylight. The picture's vigor depends on the bond between the sun, shining through the whale of a cloud, and the two tiny dots on the highway below. If you don't think so, just cover up the dots.

Before I'd left New York, it seemed clear there'd be one picture of sheep grazing among statues in Henry Moore's field. Every picture book about him had one, though none were taken in the dead of winter. Late in the afternoon, on the second day of my visit, it began to snow. "Snow's pretty," said Todd Brewster, the writer who had arranged the trip. "Too dark," I answered grouchily. I don't like people hinting about what pictures I might take.

However, Todd's comment made me notice: if there was no wind during the night, the snow would pile on the branches of the trees and the scene would be lovely when light returned. "Let's come back at dawn," I said. We did. The field was transformed. But the sheep were huddled against the woods on the far side. I tried herding them over. They moved farther away. "Would you try?" I asked Todd. Was it his Indiana upbringing? His musical talent? I don't think it was an odor, but who knows? The flock followed him across the field and clustered around him as he stood behind Moore's *Sheep Piece.*

A porter passed by in the Bois de Boulogne carrying a towering stack of wicker café chairs on his back. The column curved forward far over his head. "John, why aren't you photographing that man?" Henri Cartier-Bresson asked. Good question. Good subject. I saw Cartier-Bresson's picture. I did not see mine.

My subject was Cartier-Bresson himself. A year shy of 80, he was lithe and nimble and reluctant to be photographed. Each exposure required fresh negotiation. For instance, I could take pictures while he sketched in front of his house in southern France, but only if I did so from behind. "What else do you do?" I asked when we'd finished doing that.

"Nothing," he said. "Really. No more is possible." His wife suggested I drop by the next morning on my way to the airport. When I did, she urged her husband to do what he plainly wished I'd done the day before.

He went to fly a kite.

Index

This book is dedicated to Bob Adelman, a superb photographer, an indefatigable producer of books and a great friend.

Art Director: Michael Rand
Book Design: Adam Brown

Copy Editor: Amelia Weiss

First published in the
United States of America by
The Vendome Press
1334 York Avenue
New York, N.Y. 10021

Copyright © 2005 by John Loengard

All rights reserved. No part of the
contents of this book may be reproduced
without permission of the publisher.

ISBN 0-86565-167-1

Library of Congress Cataloging-in-
Publication Data

Loengard, John.
 As I see it / by John Loengard ; introduction
by Ann Beattie.
 p. cm.
 Includes index.
 ISBN 0-86565-167-1 (hardcover: alk. paper)
 1. photojournalism–United States. 2. Loengard,
John. I. Title.
TR820.L555.2005
770'.92–dc22

 2005011851

Printed in China

Acknowledgments

Photographers work alone but not in a vacuum. My thanks to my subjects for their patience and to the editors who assigned the stories from which many of these pictures are culled. William Bentinck-Smith and Norman Hall at the *Harvard Alumni Bulletin* were two. At *Life* I met others: Wilbur Jarvis, Frank Campion, Ray Mackland, Philip B. Kunhardt Jr., George Hunt, Roy Rowan, Richard Pollard, Richard B. Stolley, Ronald Bailey, Sean Callahan, Elton Robinson, Bob Ciano, Charles Pates, Mary Steinbauer, Mary Simons, David Friend and Barbara Baker Burrows. Also, M.C. Marden and her team at *People* magazine, Gunn Brinson of the *Sunday Times* in London, Marilyn Minden at the *New York Times* and Rick Smolan of the "A *Day in the Life of…*" book series.

Painter Jill Gill brought her astute, collagist's eye to bear on my selection of pictures and suggested a preliminary order. When publicist Judy Twersky saw the book, she immediately offered to help find it an audience. The legendary British art director Michael Rand and his collaborator Adam Brown then brought their remarkable talent to the book's final design. Onno De Jong and Michael Macioce helped me navigate the electronics of publishing, as did Frances Harkness at C+C Offset Printing. Elizabeth Kalkhurst brought discerning enthusiasm and comment to every stage. Christopher Sweet at Vendome Press wrapped things up with his warm and perceptive editorial advice. My thanks to them all.